STUDYING PHOTOGRAPHY
A Survival Guide

Douglas Holleley PhD

For Nathan

Photo Developing Volume III

STUDYING PHOTOGRAPHY
A Survival Guide

Douglas Holleley PhD

CLARELLEN

NOTE TO EDUCATORS

Clarellen can print on demand customized copies of this book for individual schools or associations of colleges and universities. Additionally, extra material can be incorporated into such books including the college handbook, documents such as access and assessment policies, or any other written and/or visual matter (such as the school logo or photograph) as desired. Bulk pricing for such orders is available.

Additionally, the author offers coaching, either individual or group, as well as lectures and workshops. Assistance with accreditation requirements and curriculum design is also available. Contact douglas@clarellen.com for further information about any or all of these services.

To order copies of this volume, or other books in the series *Photo Developing,* visit CLARELLEN.com

TR
161
.H63
2010

CLARELLEN
116 Elmwood Avenue
Rochester NY 14611
www.clarellen.com

ISBN 978-0-9707138-8-9

TABLE OF CONTENTS

9 INTRODUCTION

11 THE HIDDEN CURRICULUM
12 Over-shooting
14 Incremental Progress
15 Arbitrary Hierarchies
16 Episodic Effort and Growth
17 The Ways of Academia
18 Subtle Influence
19 Fortuitous Side Effects
21 Conclusion

23 ANALYZING PHOTOGRAPHS
 Introduction
24 The Analytical Approach
25 Description
29 Interpretation
33 The Intuitive (Patient) Approach
36 About Reading
37 The Participatory Approach
38 Picture Scrabble
41 Formal and/or Structural Approaches
42 Final Thoughts
45 Judgment

47 PROGRESSING FROM YEAR TO YEAR
 Devising a Statement of Intention

51 WRITING AN ARTIST STATEMENT

55 OBTAINING FEEDBACK
57 Coping with Doubt

59 ASSESSMENT
 On Taking Control

65 ACADEMIC HONESTY AND COURTESY
 Plagiarism
66 Camera Etiquette
68 Procedures
69 Final Thoughts

71 SELF-LIMITING TALK

74 EXCUSES 101

76 TYPES OF STUDENTS

79 ASPECTS OF PROFESSIONAL PRACTICE
 The Degree
 The Transcript
80 References
 Resume
81 Letter of Application
 Website
82 Your Work
 The Initial Application
83 At Interview or when Sending
 Original Material

87 COMPUTERS, COPYRIGHT AND THE LAW
 Copyright
88 The Problematical Nature of Computers
92 Software Copyright
 Text Copyright
93 Image Copyright
 Moral Rights
94 What Material Can You Safely Use?
95 What Material Can You Less Safely Use?
 The Doctrine of Fair Use
97 Conclusion

98 PROTECTING YOUR WORK
 Conventional Copyright—All Rights Reserved
 Creative Commons—Stipulated Rights Reserved
100 Conclusion

101 GENERAL GOOD PRACTICE

103 A NOTE ON THE ILLUSTRATIONS

106 BIBLIOGRAPHY

108 ACKNOWLEDGEMENTS

109 APPENDICES

111 APPENDIX I
 YOUR ASSIGNMENT: PHOTOGRAPHY

115 APPENDIX II
 PHOTO-EDITING AND PRESENTATION

118 INDEX

And so our studies begin. This image is from the author's book, Secrets of the Spread, *Rochester, NY: 2005. The original subject of the image is of an illustration in* Descriptive Mentality from the Head, Face and Hand *by Holmes W. Merton. Philadelphia: David McKay Publisher, 1899.*

INTRODUCTION

This book will assist students in understanding many of the developmental issues that underpin the study of photography. It will also be of use to graduate students contemplating careers as teachers, not only because of the photographic skills and attitudes it addresses but also because the book discusses, as a matter of necessity, many embedded assumptions and practices that are intrinsic to the educational process itself. For similar reasons it will also be of assistance to others, who may not (yet) be formally enrolled in a course of study.

Every assignment, lesson plan, and academic structure represents powerful, embedded value systems. These are seldom overtly expressed yet at the same time they deeply influence the way photography is perceived and learned. In the first essay we will look at some of these structures and processes that combine to form a *Hidden Curriculum*.

The remaining essays are intended to help the student successfully negotiate the many hoops and hurdles that accompany the study of photography in an academic environment.

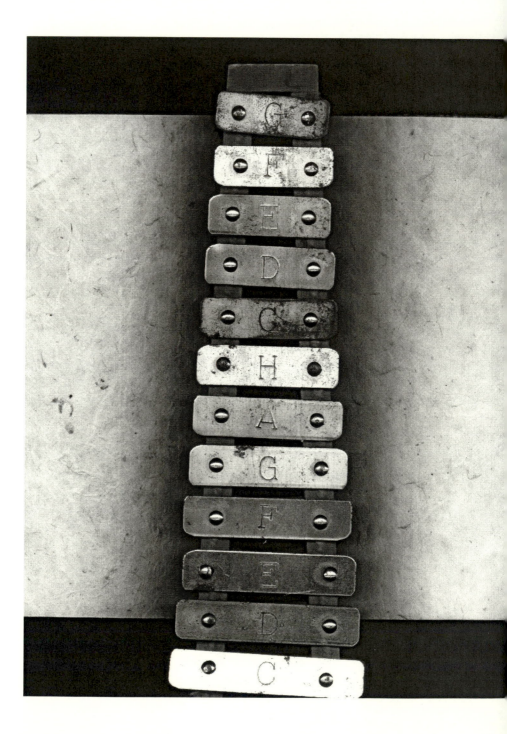

THE HIDDEN CURRICULUM

Thank Heavens for perversity.
Otherwise we couldn't count on anything!

Opposite: A direct scan of a xylophone with its own hidden curriculum. In this case, the previously unknown musical key of "H." From the author's book, Paper, Scissors and Stone. *Woodford, NSW: Rockcorry, 1995.*

In this essay we will examine certain outcomes that to a large degree are a function of the way photography is taught in universities and colleges. They can, in accumulation, form a *Hidden Curriculum.* You will observe that many of these items are a function of using 35mm photography as the basic learning tool. As digital cameras become accepted in the curriculum, some if not all of these assumptions may be questioned and/or eliminated. However, even this new technology runs the risk of being employed within a paradigm based on conventions and assumptions derived from 35mm practice. The point being that as a result of these and other factors, students acquire unstated skills and values, often by accident. Some of these are counter-productive, others are helpful. Some are even wonderful.

- Over-shooting
- Incremental Progress
- Arbitrary Hierarchies
- Episodic Effort and Growth
- The Ways of Academia
- Subtle Influence
- Fortuitous Side Effects

To each in turn:

OVER–SHOOTING

Students are taught, and subsequently come to learn, that to make a "good" image it is necessary to expose many, many images. The corollary is that only one image per roll (or digital session) is going to be any good!

It is a fact that making a variety of photographs from a variety of viewpoints can increase one's chance of obtaining a successful image. But the obvious trap is the implied admission of chance into the image-making process. In saying this I am not arguing that chance is a bad thing—often the surprises on a roll of film are the most satisfying. However, an over-reliance on a "shot-gun" approach does little to promote thoughtful growth. In fact the direct opposite can be the case. All too often the temptation exists to simply blast off many images in the hope that one or two may work.

Certainly it can feel good to say, "I shot five rolls over the weekend."* However, if these five rolls were exposed thoughtlessly and with little consideration for the quality of light, then there is every chance that not one of the frames so made is usable. When I was at graduate school one of my fellow students once made the observation that, "activity is not necessarily work." I am not arguing for a situation where it is sufficient to go out into the world and make one or two images—far from it. I am simply saying that quantity without thoughtfulness may well be inferior to 20, even a dozen, well-considered exposures. Yet there are even more dire consequences than obtaining 150 or so unusable images. Of these the most disastrous is the effect that such a practice can have on your thinking when it comes time to select images to print.

You will recall in the summary (in italics above) that the corollary of the "shot-gun" approach is the thought that as a result it is unlikely that there will be more than one, maybe

* *It is worthwhile, for a moment, to consider the use of the verb "to shoot" when describing the act of photographing. This word is intrinsically offensive and aggressive. Instead consider how your attitude toward photography changes when you use other verbs to describe this act. How different is it to* make *a photograph,* expose *a photograph, or even* permit *a photograph. It is an interesting exercise to consciously remove the word "shoot" from your vocabulary altogether when talking about photography. If you can do so you will be surprised how foreign, and indeed, distasteful it is when others use it without thought. For more discussion on this notion see the author's book,* Your Assignment: Photography. *Rochester, NY: Clarellen. 2009.*

two images on any one roll of film worthy of printing and/or further thought. This is a pernicious notion but is surprisingly difficult to shed. Because the practice of highly selective editing is so necessary if one "shoots" a large number of images, the thought begins to take shape that it would be virtually impossible to expose a roll of film wherein each image, or a large proportion therein, has validity. Even when this does happen (and it does happen surprisingly often) there is often great resistance to accepting this outcome as having any merit.

Reasons vary; it can seem like cheating, it is statistically impossible, it is not what is being asked for by the teacher, it is too easy. None of these excuses (more properly perceptual and/or cognitive blindness) have any real weight. They are simply a function of the *Hidden Curriculum.*

Often I have seen examples of wonderful visual interactions with the world that are sustained through entire rolls of film—and as often as not I have watched the student painfully attempt to find the image that is "the one," or "the best." Even when reassured that all are of interest (and indeed all, even if of the same object, scene or subject, are different to each other) it can often take the student weeks, even an entire semester and sometimes never, to accept with grace the gift that he or she has presented to him- or herself. This graphically shows just how ingrained certain attitudes can become, and how little direct (conscious) effort is needed to teach, learn or unlearn them.

Note: According to Juan Eduardo Cirlot in his wonderful book, A Dictionary of Symbols, *(New York: The Philosophical Library, 1962) multiplicity represents the farthest point from the Source of all things and hence is negative in character. Consider this when you are next tempted to blast off "a few rolls."*
Image below from The Sears, Roebuck and Co. Catalog. *Chicago, IL: 1902.*

INCREMENTAL PROGRESS

Students learn to give themselves feedback in a series of hierarchical steps, especially when using 35mm photography.

Stop to think what the shape of your photography learning experience would be if there were no 35mm cameras or no digital cameras. Instead, consider how different the experience would be if you learned photography using only a 4"x5" camera. Would you take this behemoth out into the world and blast off 30 frames? Would you then make a set of proof sheets, discard 29 of the images, proof print the remaining frame, do the same thing again for the remaining weeks of the semester, and then and only then, with a week or so to go, set about making a set of "exhibition quality" prints for the final assessment? Pretty unlikely! More likely you would make a smaller number of images, print each one carefully, and slowly but surely acquire a respectable number of prints as you put each finished print into a box for safekeeping and reference.

Above: Image from The Sears, Roebuck and Co. Catalog. *Chicago, IL: 1902.*

An essential part of the *Hidden Curriculum* in most photography courses is a process where the final print is something that is slowly approached only after going through a number of proscribed processes and judgments. These include looking at the negatives, making a proof sheet, making a proof print and finally, usually toward the end of the semester, making a final large-scale image. This work path is widely encouraged but it arguably works against the more important processes of reflection and editing.

I ask the reader to consider another way of proceeding. Why not simply make a decent print from the beginning instead of a proof? It makes more sense to simply print the image at a decent size, take a small amount of extra care, and then place this image in a box. If you do this, by the end of the semester you will have a large number of finished prints from which to choose and there need not be that last-minute frenzy of printing. In this way the final weeks can be spent reflecting and editing rather than printing in a panic.

ARBITRARY HIERARCHIES

In most institutions students learn an artificial hierarchy based on the practice of teaching black and white before color.

Most photography courses begin with a semester called something along the lines of *Basic Photography* or *Introduction to Photography*. Almost always such courses prescribe the use of a 35mm camera with manual controls and involve learning how to process film, make a proof sheet and make a print. Almost always, such courses are conducted in black and white. Here again, values are being taught that are incidental to the stated aims of the courses.

The most obvious of these is that black-and-white photography is somehow more "basic" than color photography. To an extent this is true, but only from a technical perspective. Although loading film onto a spiral in pitch darkness takes a bit of getting used to, and although making a good print seems relatively easy but is actually quite difficult, the real reason, I suspect, is because all of the steps can be done in a hands-on way. It must be conceded that this does provide a good all-round introduction to the basic processes of the medium.

However, from a conceptual perspective, nothing could be further from the truth. In my opinion black-and-white photography is infinitely more difficult than color photography. It requires the student to engage with complex issues of abstraction, reduction and a re-jigging of their perception to be able to truly see the world in terms of light patterns while attempting to ignore the more obvious cues and clues of natural color. In my experience, unless there is a very determined attempt on behalf of the teacher to explain the high degree of abstraction that is involved, and the supreme importance of light and/or its absence in the creation of visual structure, then students simply continue to see as they always have and as often as not the work manifests a persistence of seeing and responding to color while the film indifferently transcribes these observations in simple black and white. As such, the images become a catalog of "things" rather than a record of

visual perceptions. Yet while all this is occurring the student learns that this is somehow the basic aspect of photography. It is also at this level, and very much a function of this process, that some of the issues discussed above, such as over-shooting, incremental self-feedback and hierarchical work patterns become ingrained without seemingly either the student or the teacher noticing that this is occurring.

No. 2

No. 2½

EPISODIC EFFORT AND GROWTH

No. 3

Students learn to work episodically in cycles that are based around the length of the semester. There are a number of consequences that ensue.

The structure of the academic year is itself a learning experience. This is not something you can do anything about other than realize that it causes your thinking to be episodic in nature. Unless you are hyper-organized and single-minded, the "end" of your project will be determined by external forces (the timetable) rather than the intrinsic logic of the work. A couple of things can happen. In the last-minute rush, often images will be selected that perpetuate pre-conceived notions of what is perceived to be "good," or those that fit verbally stated intentions. As such, valuable clues are often overlooked, and interesting images remain out of sight because they "don't fit." As often as not they do, it's just that there is insufficient time to look at, reflect upon and absorb these new directions.

Above: Image from The Sears, Roebuck and Co. Catalog. *Chicago, IL: 1902.*

Secondly, what also often happens is that in the following semester one proceeds to automatically do something new rather than be sure that the previous edit (imposed by the timetable) was the best solution. Instead, ask yourself some questions. Did the rush at the end cause you to miss important clues? Having distanced yourself from the work for a few weeks (or months over the summer) do you now see the work in a different light? To automatically "do something new"

Below right: Image of an electric belt guaranteed to be a quick cure of all nervous and organic disorders. Regrettably they are no longer available as they sound ideal for the end-of-semester blues. The Sears, Roebuck and Co. Catalog. Chicago, IL: 1902.

can mean that many rich and fertile ideas go under-developed and that fruitful lines of investigation are allowed to atrophy prematurely.

To be fair, doing something new is often the best strategy. However, particularly in the senior years, it is good practice to look at the essay on *Progressing From Year to Year* (page 47) and adopt the procedure outlined therein. This will quickly give you some idea about whether it is a good idea to stick with something or instead attempt a new approach.

THE WAYS OF ACADEMIA

Students learn that the ways of academia are themselves a part of the curriculum.

** Only partially jokingly I have confided to my graduate students the first rule of academia. It goes something like this: "When you find yourself 'sucking-up' so badly that you are convinced that your peers are looking on in horror at your level of sycophancy, then it's a sure sign that it's time to re-double your efforts!"*

Certainly one of the things a degree demonstrates is the fact that the holder has learned sufficient self-discipline to follow instructions and satisfy a series of graded criteria. Employers know this and reward this with extra remuneration. Rightly or wrongly it also means that the graduate has learned just how authoritarian a structure a university actually is, and by implication, just how important it is to somehow "please" authority figures. These are all useful real world skills but to reflect on them is a little sad.*

SUBTLE INFLUENCE

Related to the above: Students will attempt to produce work that pleases their teachers.

This can take a number of forms. Some students will question endlessly what is required in order to produce work that they think the teacher will like. This is an admirable (even flattering) sentiment but a real problem when it comes to the student developing something that resembles a personal vision. When questions of this nature are presented it is very tempting to answer at least one or two. However, this merely encourages a dependent approach.

Misunderstanding can also occur when a casual remark is perceived by a student as being firm, considered advice. From a teacher's perspective, you realize this happens when you see something unexpected, or it looks like things have gone off in a completely different direction and you question the student as to "why?" If he or she replies along the lines of "because you said X, Y or Z," then suddenly you have the terrible realization that students do actually listen, even though most of the time this can't possibly seem true!*

This problem/issue can work at a group level as well. This tends to occur in the senior years of undergraduate study or at graduate school when the structure of the program is more open-ended. Over coffee, during lunch or perhaps even at a bar, discussions about what is expected, how should pictures "go together," and again, "what does the teacher(s) want," are common. Over time a sequence of impressions and perceptions from a variety of student perspectives begin to coalesce into an unstated, but surprisingly resilient set of expectations that effectively becomes a default curriculum entirely of the students' own making.

Sometimes these expectations are in line with the teacher's intentions. Other times however, they can form an almost grotesque parody. Minor issues can become elevated in importance and completely monopolize student's thoughts and

** This most often occurs when the student is accustomed to a rigid academic structure (like high school) and is having trouble adjusting to a more independent environment. In most cases this dependence slowly evaporates as people "get the hang of things." However, sometimes more extreme measures become necessary. As a teacher, one thing you can do is to create an assignment that is difficult, open-ended in terms of outcome, yet maddeningly precise. e.g. Imagine that your thoughts have structure. In fact they most likely do. Try to visualize the web of neural connections within your brain that evoke thoughts of beauty, thoughts of fear, or thoughts of joy. Then go out into the world and find shapes that correspond to these structures.*

actions. It is this way schools can develop a "house style." Beware of groupthink.

FORTUITOUS SIDE EFFECTS

The Hidden Curriculum teaches skills independent of the discipline being studied that are perhaps more valuable than the expressed content itself.

Note: Sometimes it can seem that there are too many rules. However, as the discussion shows, often what seem to be rules are instead unintended consequences of the educational process. They are assumptions rather than directives. Therefore, be flexible. Never forget that when it comes to art practice: The only rule is that the rules change.

The discussion to this point has concentrated on some of the more unfortunate aspects of the *Hidden Curriculum*. However, there are many wonderful, useful and even joyous consequences as well. Certainly one of the difficult aspects of teaching and studying the visual arts is the assumption that we are teaching art students to be "artists." Not unreasonably, students pay good money to be taught the skills and materials of the discipline so they can apply these to professional practice upon graduation. But it does not automatically follow that by studying art one learns to be an artist—this is a lifetime task and in many ways can't be taught at all.

Right: The afore-mentioned electric belt being modelled by a vigorous youth. His (sic) heroic pose and inner confidence suggests that truly, here is an artist in the making. The Sears, Roebuck and Co. Catalog. *Chicago, IL: 1902.*

So, if this is the case, what is really being taught? Why does the process work as well as it does if it cannot do that which we think it is doing? The best way to address this is to list the things that can be taught, and the things that cannot. Sometimes these are stated in the regular curriculum. However, more often they are not. Although these are presented in discrete categories, as these skills and values become internalized, they become part of one's very self.

Things that cannot be taught:

1. How to be an artist.

Things that can be taught, yet are seldom stated:

CRITICAL THINKING SKILLS

1. How to critically evaluate images both in the general cultural environment and within one's own discipline.
2. How to accept and employ criticism of one's own work.
3. How to critically evaluate one's own images.

CREATIVE PROCESS SKILLS

1. How to adapt to changing circumstances and embrace new (and sometimes old) technologies.
2. How to conceive, initiate, develop and complete a self-directed project.
3. How to recognize and address the gap between intention and effect in one's own work.
4. How to edit and shape these images to exhibit the quality of thoughtful authorship.
5. How to employ presentation techniques to communicate effectively.

COMMUNICATION SKILLS

1. How to make visually coherent images.
2. How to express oneself in writing as well as images.

PERSONAL AND PROFESSIONAL SKILLS

1. How to cooperate with others in a communal situation. In the past the shared darkroom/workroom was excellent in this regard.
2. How to listen to other points of view.
3. How to accept responsibility for one's work and actions.
4. How to respect the work of others.
5. How to protect and defend one's own efforts.
6. How to cooperate with one's peers and connect with a general audience through group shows and other community outreaches.
7. How to solve problems.
8. Above all, how to work hard and appreciate the vast difference between an ordinary effort and a super effort.

CONCLUSION

Learning photography is far more an art than it is a science, even in the most technical of institutions. As can be seen, there are many aspects of the process that can bias your thinking and cause unhelpful rigidities to creep into your thinking. Many, if not most of these, cannot be eliminated. However, they can be acknowledged and made conscious rather than simply allowed to lurk in the back of your mind as a collection of unstated assumptions. Others are marvellous, and above all useful skills that will help you develop your career.

Above left: It is unlikely that all of this is going to come together in a flash. However, the cumulative effect of all of these highly learnable skills will in time, with practice, pay off. From The Camera. *Philadelphia: The Camera Publishing Company, November 1918. Volume 17, Number 11.*

The skills one employs when analyzing images are qualitatively different from the skills one employs when making images. The former are more conscious and considered. The latter more intuitive and even unconscious. Many problems arise because these two skill sets are not seen as the two separate cognitive processes that they are. Both are necessary but they are very, very different. Image from The Accessory Sinuses of the Nose and their Relations to Neighboring Parts. *Dr. Gustav Killian. Jena: Gustav Fischer, 1904.*

ANALYZING PHOTOGRAPHS

INTRODUCTION

The analysis of photographs is not just about criticizing art. It should be an ongoing process. Daily, hundreds if not thousands of images impinge on our consciousness. Billboards, television, newspapers, web pages and books bombard us constantly. It is essential to be an active consumer of this passing parade. Try to make sense of this onslaught by asking: "Who is showing you what and why? Who is trying to inform? Who is trying to persuade? Who is trying to make you purchase the objects or services depicted? How did merely viewing their image create a void in you that you desire to fill? Who is trying to frighten you?" How many or how few of these images make you feel good? Is it possible we are watching the very image of the pursuit of happiness—ending up spectators rather than seekers?

Perhaps this is all exaggeration. More likely we have trained ourselves not to look at anything or everything in any detail. However, this is not say that there will be no effect. At minimum we learn to disregard the message, occasionally stopping to applaud a particularly arresting or skillful use of the medium. At worst, nothing means anything anymore. More likely, perhaps everything ends up meaning nothing.

As visual arts practitioners we cannot allow this to happen. We cannot remain oblivious to the content that is being communicated. It is essential to make a determined and conscious effort to understand the message of the image(s) under consideration. There are four main ways to approach this task. They are:

1. The Analytical Approach
2. The Intuitive (Patient) Approach
3. The Participatory Approach
4. Formal and/or Structural Approaches

I. THE ANALYTICAL APPROACH

When asked to respond to either a colleague's work, or the work of an established photographer, avoid extremely unhelpful terms like "good" and "bad." The reason these two words are so problematic is that such words terminate further discussion. Essentially they are (usually quick and superficial) judgments—and judgments should come at the end of a discussion, not at the beginning. Even seemingly harmless statements such as "I like it," have no place in a learning environment, especially as an initial response. They may serve the function of making your classmates feel better but they will do little to facilitate intellectual growth and understanding. It is far more useful to avoid such words altogether.

Instead, you will find it easier to respond if you approach the process with patience and thought. Before coming to any sort of conclusion it is essential that you engage in two prior steps. The first of these is description. The second is interpretation. These two words represent dovetailing cognitive functions yet are frequently confused with each other. It is important to realize that they are two interrelated but nevertheless distinctively different modes of thinking. Articulating a response to imagery is made much easier if you remember that if you wish to understand something (anything?) then simply describe it first.

Above Left: From The Camera. *Philadelphia: The Camera Publishing Company, November 1903. Volume 7, Number 12.*

DESCRIPTION

Below: An image from the Encyclopedia of Source Illustrations, *a facsimile volume comprising all of the 266 plates contained in The Iconographic Encyclopedia of 1851. Hastings-on-Hudson, NY: Morgan and Morgan, 1972.*

For example, how do we understand our dreams? When we dream we are flooded with images, sometimes overwhelmingly. But when we awake, these images are gone. In order to make sense of them we often turn to friends, or even a psychologist to assist us to understand their meaning. To do this we must describe the dream. In doing so the complexity and sensation of the dream is turned into a narrative. The very act of description orders the experience as we communicate the plot, images and outcome of this dream in order to understand its meaning. As a result, by simply relating in one's own words the perceived nature of this event, the act of description itself begins to clarify meaning not only to the person to whom we are telling the story, but also to ourselves.

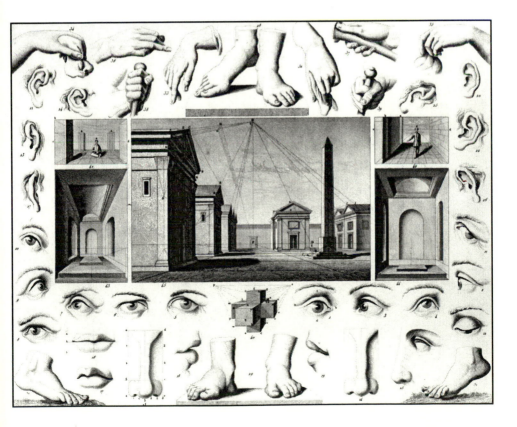

Compare this to a hypothetical situation in the future where it might be possible to place on one's head a kind of mental recorder that can capture and store all the impulses of the brain during sleep. This would enable us to share not just the story of the dream but to actually re-present it in all its complexity, color and sound. The corollary is: would this make things easier or more difficult for either party? Would your friend or the psychologist, in possession of the entire sensory experience, find it easier to come to terms with the personal symbolism and the effect of this symbolism or would instead the direct experience be so overwhelming and alien that the very precision and completeness of the information make further interpretation almost impossible?

In many ways photographs are dreams that have been fixed in time. However, unlike a dream, the photographic image does not disappear when daylight arrives. It is there, in front of one's eyes, always in the same form whenever we look at it. It is probably for this reason that we do not see the need to describe it, yet describe it we must.

Although the process of description seems simple, even objective, seldom do two people describe the same image in the same way. When you describe the complex visual artifact that is a photograph, you automatically assign hierarchies of value to the image. What you choose to describe first, the words you choose, and the emotional quality of these words, are particular to you. Do not assume that just because the photograph is a fixed and immutable fact, that it will be seen the same way by a variety of people. If you omit this step, it is unlikely you will ever get to the next level. You do not necessarily have to even verbalize at this stage. Just simply articulating to yourself what is going on in the image as you see it can be sufficient.

Do not however, limit this process to simple recognition of the objects in the photograph. The process of description must include a sense of the *appearance* of these objects, not simply their mere presence, or even their relationship(s) with each other. For example: "What do these things look like? Does something in the image appear to look like something else? What is this something else? How does the way they are illuminated participate in the content? Are they shown in a good or bad light? Do things seem intimate or remote, threatening or reassuring, etc.?"

Opposite: Capitalize on the metaphor of dreams and employ Freud's distinction between the manifest content and the latent content of dreams. The manifest content is the shape, structure and narrative of the dream. This corresponds to the photograph. The latent content refers to the themes and motivations underneath. This corresponds to the next stage of the process, i.e. interpretation. Image from the author's book, Secrets of the Spread, *Rochester, NY. 2005. The original subject of the image is of an illustration in* Les Mille & un Tours, ou Expériences de Physique Amusante et de Magie Blanche. *Paris: ANA-GRAMME BLISMON, 1869.*

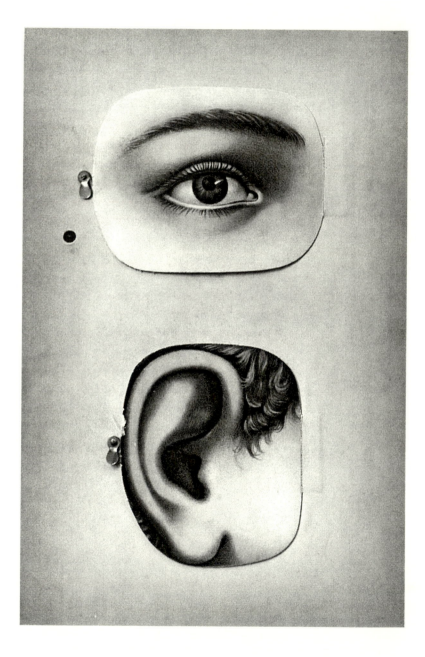

INTERPRETATION

Opposite: When interpreting photographs in the class when the author is present, listen carefully with both your eyes and your ears! Make sense of all the data. Image from Physicians Anatomical Aid. *London and New York. H. Andrews, Gen. Agent, Auckland, N.Z.: c. 1895.*

Interpretation is the act of coming to an understanding of the themes and messages that lie behind the photographs under discussion. To do this successfully it is important to distinguish between the *objects* in the image, and the *subject* of the image. Quite frequently, these two words are used interchangeably. However, they are two very different concepts.

The objects in the photograph are the nominal subject matter. However, depending on how they are rendered by the camera, in what light they are shown, and in what context they are presented, the actual subject of the photograph can vary widely. For example, consider an image of flowers.

If this image of a flower is on the front of a Christmas or birthday card purchased in the Hallmark store there is every chance that the underlying message is one of sentimentality, friendship or even romantic love. If however, we look at one of Robert Mapplethorpe's images of a flower, the subtext is far more complex. The emotional state communicated is more likely to be a strange mixture of ambiguous sexuality and an almost Victorian obsession with languid decadence. In this example it is abundantly clear just how important the act of detailed description is in this process, for to simply generalize and say "flowers" in view of the above would be to completely misconstrue if not confuse, two almost opposite world views.

PAGE 30 STUDYING PHOTOGRAPHY: A Survival Guide

To further differentiate between the object and the subject it is helpful to borrow two terms from the field of psychology. To return to the metaphor of dreams, let us look at how Freud* described this distinction in the context of dream interpretation. Freud termed the dream as related by the patient (in our case read "the photograph") as the *manifest content*. The narrative, objects and events of the dream are its outer manifestation. However, underneath this parade of objects and events lies the deeper meaning of the dream. Therefore, if we look at these objects and events, not simply as "things" but instead as symbols and metaphors, then we can begin to decipher the (psychologically real) underlying message. This message Freud describes as the *latent content* of the dream. This process involves relating the images to larger theoretical perspectives.

* *Freud, Sigmund.* Revision of the Theory of Dreams *in* New Introductory Lectures on Psycho-analysis. *New York: Carlton House, 1933.*

There are many perspectives one can adopt when interpreting images. Terry Barrett° lists several in his book *Criticizing Photographs*. I have also added to his list. All of them represent conceptual and/or theoretical ways of explaining, or making sense of, the world. Which one or which combination you choose is up to you. Ultimately your choice will reflect your own world-view and set of values. Therefore consider the following list as a starting point. The more you can refine a set of values that is relevant to you, rather than simply apply any one or more at random, the more helpful and more meaningful the whole experience will become.

° *Barrett, Terry.* Criticizing Photographs. *London and Toronto: Mayfield Publishing Company, 1990.*

- Psychoanalytic Interpretation. Interpretations based on psychological imperatives. Extended self-portraits either literal or metaphoric are one example.
- Semiotic Interpretation. Use of signs and symbols that have a primarily public, i.e generally agreed, meaning.

Opposite: The process of interpretation is not just about images. The photograph shows part of an elaborate castle built single-handedly by a Latvian immigrant by the name of Edward Leedskalnin in the mid-20th century near Homestead, FL. The castle exhibits many mysterious symbols and signs. Theoretically, one should be able to integrate these symbols with the architectural structures and decode the message. However sometimes, like many of the great images in the history of photography, the true meaning remains inscrutable. The Transit. *Image by the author, 2008.*

As a start, ask yourself some questions. For example: What larger themes do the images address? Are the images either literally or metaphorically an extended self-portrait? Are they evidence of the artist addressing issues connected with his or her personal or cultural background? Do they address more general and shared sociocultural themes? Do they address themes you have read in literature or seen in movies? What is the perspective of the author of the images? What questions are you prompted to ask the artist?

- Social Theory Interpretation; e.g., Feminist, Capitalistic or Marxist perspectives. An analysis based upon the degree to which the images either reinforce, or question, structures of power within society,

- Interpretation based on Stylistic Influences. Are the images made in a recognizable style? What assumptions and values accompany this style?

- Biographical Interpretation. Do the images reflect the life experiences of the author of the images?

- Interpretation based on stated intention(s). Do the artist's stated intentions count? Do they clarify or undermine the reading of the work?

- Art History and/or Theory Interpretation. Do current, or indeed old theories of art help explain the nature and content of the subject?

- Moral and/or Spiritual Interpretations. An analysis based on more abstract, even religious criteria.

- Archetypal Interpretation. Do the images tell us something about mythical and/or universal themes?

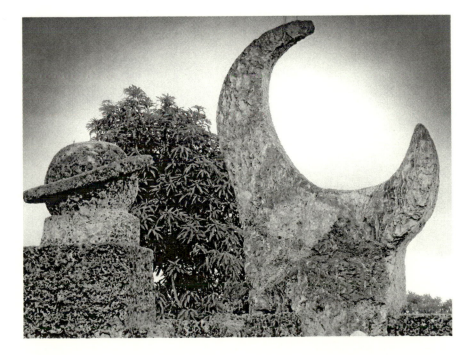

As important as it is to listen carefully to what is being said when formulating a response, at the end of the day, let your eyes do the talking. The Silence. *Image by the author from the book,* Secrets of the Spread. *Rochester, NY: 2008. Original source is a page from* Descriptive Mentality from the Head, Face and Hand *by Holmes W. Merton. Philadelphia: David McKay Publisher, 1899.*

2. THE INTUITIVE (PATIENT) APPROACH

The reader will observe that the previous approach used a lot of concepts and asked a lot of questions. In other words, it used a lot of words to discuss what is, or should be, a visual medium. In saying this I am not advocating a reversion to the modernist idea that a successful photograph needs no explanation. However, it is an interesting paradox that much contemporary visual education practice relies overwhelmingly on the verbal and written word, often way out of proportion to the importance of the image itself.

This manifests itself in *Statements of Intention* and *Artist Statements* that frequently monopolize, and indeed overwhelm, a straightforward appreciation and subsequent reading of the image. The paradox of course being that an image that is permitted to "speak" and subsequently be "heard" can in fact generate much thoughtful discussion when its message is finally assimilated. However, what often occurs instead is an overly literal emphasis on the written or verbalized statement, and a minimal effort directed to actually seeing and reading the image that the words are supposed to clarify.

I say "supposed" as often as not that which is said is quite simply wrong. Frequently these statements are a hodgepodge of art-speak, wishful thinking, groupthink, pretentious garbling and poorly grasped theoretical concepts expressed in selective and deliberately obscure jargon. The unintended consequence of this process is that often valuable (visual) insights and other helpful ideas are overlooked, both by the student who rejects any image that does not fit the abstract, theoretically constructed set of verbally expressed intentions and the teacher, who values clarity of idea, yet seemingly cannot accept that clarity can be expressed in ways other than words.

Hence the suggestion to employ a more "intuitive" approach when interpreting images. One frequently hears commentators proclaim that we live in a visual age. The ready availability of media, especially visual media (is texting a visual medium?) on portable devices is held up as an example of how our culture is supposed to be somehow "more visual." I have a few problems with this assertion, if not assumption. It is strange how in pre-industrial revolutionary times the under-educated, illiterate masses were treated to visually rich churches and cathedrals that "told the story" or manifested the values of the prevailing religion in purely visual times. This, we are told by art historians, was because the illiterate population could not otherwise be made aware of these values. Thus the implication is that information expressed visually is somehow simpler and more direct.

Yet now, in this so-called visual age, we have a situation where apparently this simpler and more direct form of communication cannot be read and understood unless we have words to explain it to us. This results in interesting paradoxes in addition to the ones we have already discussed. Consider now how contemporary visitors to these same churches and/or their relics housed in museums plug into their ears tape-recorded or podcast commentaries that explain to their eager ears what their eyes should be seeing.

It is hard to explain why this phenomenon should be so widespread. One possible reason is that we feel that there must be a "right" way to see these images. (As if a single narrative, no matter how authoritative, could tell the whole story.) More likely, it is just impatience. Why sit down and decode a visual message when the voice in your ear tells you in a microsecond what it is you should be seeing? Most likely we could figure this all out as well as a 16th-century uneducated rustic, but why bother?

The point of this polemic is simple. Take a deep breath, get comfortable, and look at the work. It is surprising how much comes to those who wait and look. This is not to say that an inner dialogue that does a little silent describing and analysis doesn't hurt. However, it is surprising how much comes when patient observation is employed. Perhaps we don't get it quite as fast as the young man who observed in an instant that the Emperor had no clothes, but it won't take much longer.

Ask yourself, "Why do I think I have to 'get' an image, especially a photograph, instantly?" (For the answer, read on.)

Opposite: The Message. *Image of the Carmelite Monastery near Santa Fe, NM. Image by the author, 2004.*

ABOUT READING

Probably the first experience you had reading photographs was as a child. You were given a book with an illustration on one page, and on the facing page there was most likely a single word. This word would usually be set in large, legible type. The function of this book was to teach you, the young child, how to read.

The image functioned as a device to help you decode the collection of letters on the page. There was no reward for appreciating this image, but parental accolade followed every instance when it seemed you were able to read the word. In fact the sooner you could read it without reference to the picture, the more you were encouraged. That strange little collection of signs had a meaning that transcended the particular image that was being observed. A picture of a curled-up sleeping hound, a poodle dressed in circus regalia jumping through a hoop, a collie, a retriever, a working sheep dog, all could be subsumed under the label "dog." Past a certain point your skill improved to the point where the image need only be barely looked at. A glance was sufficient, once you learned the rules of the game. You were learning to read.

But more importantly, other things were also being learned. You were not just learning to read words; you were learning how to read images. You learned that:

- images are less important than words.
- to understand an image it is sufficient to identify the objects within it.
- images can be looked at, and comprehended, quickly.

The argument on this page is
excerpted from the author's book,
Digital Book Design and Publish-
ing. *Rochester, NY: Clarellen, 2001.*

3. THE PARTICIPATORY APPROACH

Above: Image from The Sears, Roebuck and Co. Catalog. *Chicago, IL: 1927.*

This is a strategy that can only be employed in the classroom. What I am suggesting is that when work is being discussed, you and fellow class members actively interact with it, rather than sit passively and accept that which you are looking at without question.

After securing the permission of the presenting artist/student, actively try other choices. Move the images around. Put them in different configurations, change their order and see if viewing them in a different sequence changes the meaning. Try arranging them in a grid so that connections are formed on a vertical axis, not just on a side-by-side basis. See if different thematic concerns emerge that were previously invisible. For example, apply purely formal connections in work that is subject based and documentary in nature.

If this is done in a manner that is respectful and driven by curiosity, it is surprising what insights can emerge. Essentially we are looking for clues and connections that derive from the work itself, not the verbally stated intentions of the author of the work.

PICTURE SCRABBLE

The reader may wish to consider adopting the approach de-
vised by Ed Lepler. Lepler was a thoughtful educator of young
children. He devised a number of intriguing games that asked
the child to read, if not understand, visual images—rather
than use them as a device to learn to read words. Of these,
his game *Picture Scrabble* is particularly useful. In its original
form each player is dealt a hand of some ten or so images. The
object of the game is to place images together in much the
same way you place Scrabble® tiles together. Like Scrabble,
if a tangent presents itself, then start another line of images
and place them perpendicular to the initial thread. Each player
in turn places an image next to the previous picture. If there
is no dissent, the following player places another image. If,
however, an objection is raised, the player who placed the
questioned image must explain why he or she chose to place
that particular image in the sequence.

In the classroom the game can be adapted to actively in-
teract with the work under discussion. Each class member can
take turns and place one image next to another independently
of the original order and expressed intention of the author.
Observe how new threads emerge and the subsequent mean-
ing of the images changes in response. Give the pictures per-
mission to do the talking.

*This procedure is excerpted from the
author's book,* Photo-Editing and
Presentation. *Rochester, NY: Clarel-
len, 2009. It is based on one of Ed
Lepler's games described in* The Visual
Ed Gameplan. *Afterimage. May/June,
1976.*

Above: The game of Picture Scrabble *in progress. Observe how liberating it is to permit tangents to emerge rather than feel the necessity to adhere to the convention of a linear sequence. These tangents can often offer important clues for further growth and insights into meaning. Doing this with others present frequently sheds new light on work thought to be finished, at a dead end, or even about something else altogether. Image by the author.*

When we make a photograph, we are also making a picture. As such, the kind of visual analysis (or in this case more correctly, explanation) of the image's geometry is appropriate and helpful. Van Vrederman de Vries. Perspective. With a New Introduction by Adolf K. Plaaczeck. *New York, NY: Dover Publication, Inc. 1968. (Reprint of 1604/5 book.)*

4. FORMAL AND/OR STRUCTURAL APPROACHES

When we make a photograph, we are also making a picture. Although sometimes photographs look like windows to reality the fact is they are images, and can and should be discussed as images, in the language of images. All too often the photograph is simply perceived as a kind of surrogate for the reality it depicts. Thus the discussion can quickly turn into a debate about this reality, independently of the way it is imaged, and the photographs subsequently turn into a kind of shopping list or inventory of (other) things. In other words the images catalyze a debate about that which is not present in the room!

However, photographs do not directly re-present a prior reality in surrogate form. They show instead the appearance of these things from a particular viewpoint, at a particular time, through the agency of light.

No matter how much it seems you are showing trees, bodies, rocks or water in your photographs, you are not. What you are actually showing are patterns of light, rendered by a lens on a two-dimensional, light-sensitive surface. Those trees, bodies and rocks do not and cannot directly impress themselves on the sensitive surface of the film or digital chip. Only the light reflected off these objects is recorded. If there is no light, there is no image. The corollary is that the pattern of light so formed is the content of your photographs.

This is the crucial aspect of photography. Until this is truly understood, your images and how you perceive them will be rooted more in what you know about your subject matter rather than what you show about your subject matter.

Therefore, a discussion of the *shapes* on the page is a vital part of the equation. Similarly, other visual criteria of balance, line, tone, color, etc., are equally valid considerations. They are only out of place when they become the sole criteria for judging the success or otherwise of any particular image. The effort must always be made to read the whole message and not simply indulge in a barren search for form alone.

FINAL THOUGHTS

There are two main forums where images are discussed. They are:

- The Formal Written Critique
- Class Feedback and Criticism

The formal written critique is best addressed by adopting the *Analytical Approach*. However, the class situation is a more fluid and interactive situation and it is likely that a combination of all the approaches discussed in this chapter will be required. This is because the presence of the maker of the images alters the dynamic in a way quite different to criticizing a published book or public exhibition. Unlike the remote authority of the absent persona in a book or show, the presence of the artist requires a consideration of his or her own perception of the work. This perception is usually expressed as an *Artist Statement* or at least some kind of contextualizing narrative or mini personal history.

Therefore, in the class situation it is essential to "listen" equally to what is being said by the work itself as well as what is being said verbally. It is surprising just how often these two "voices" get out of synch. The message of the photographs can come from a variety of sources within the individual artist. Subconscious motivations and dynamics, reflexive responses to the world and other messages from the shadowy underworld of our being, mix with our more conscious mind to create often complex images with themes that are sometimes difficult to even see, let alone interpret. In contrast, the verbal narrative or statement comes more or less directly from the verbal, rational left side of the brain. It is no wonder that they often get out of alignment.

Where problems occur is when the apparently rational verbal narrative is taken at face value as being the true arbiter as to what the work is really all about. Sometimes this can be the case but more often, the images and the words—two statements if you like from the same individual, do not coincide and reinforce each other. This is an intrinsically problematic situation.

If you listen to the verbally expressed intentions and desires you will be looking at the work through this "lens" and will be looking for images that substantiate this position, and any subsequent comments, as often as not, will be directed to how the images can be better refined or expanded to "fit." The tragedy, if this should happen, is that legitimate, even crucial images can be edited out and their message ignored.

It is far more helpful, at least in the first instance, to keep the visual message separated from the verbal message. Look and listen carefully to each in turn. Then examine where they complement each other and where they are in conflict. It is my preference to give more weight to the message of the visual images. Other, more cognitively-oriented teachers, may insist that the work follows closely the expressed intention. There will always be argument on this matter. However, I would make the case for the more visual approach for the following reason.

I have observed that frequently students will present only the images with which they currently feel comfortable talking about. In other words they may have many valuable and interesting images but not show these, or minimize their importance, not because the images are bad, but because the student has not yet been able to find the words to imbue them with the gravity and authority that the *Artist Statement* is supposed to grant them. It is always worth asking what other work has been done, and to encourage the student to put this work up for discussion along with the work that is perceived to be more "finished" and more "understood."

Surprisingly often, the prints hidden in the box are infinitely more interesting than those on the wall.

Finally, as well as considering the words that accompany the images, also evaluate their internal visual context. How well and in what way do the photographs go together? What is the nature of the relationship(s) from image to image within the group? In other words, make sense of all the data. Don't just look for, nor reward the myth of "the great image." As my former teacher Nathan Lyons advised, don't just *look* at the individual pictures but instead *read* the message of the entire body of work. Think carefully about this distinction and appreciate how one's thinking changes when the discussion is focussed on the communicated content of a group of images rather than searching for singular sensation and effect.

To repeat, take the time to balance the visual and the verbal in the classroom when analyzing work. In the same way the map is never the territory, the word is seldom the same thing as the image.

A useful experiment is to conduct a critique where only questions may be asked of the person presenting his or her work. Comments, suggestions and judgments about the work are not permitted. Almost invariably the most illuminating information is elicited by simply asking, "Why?" This strategy has been given a name by Marnie Shindelman of the University of Rochester. She calls such a forum Jeopardy Crits.

Above: This visual/verbal conundrum is from The Sears, Roebuck and Co. Catalog. *Chicago, IL: 1902.*

JUDGMENT

Irrespective of what approach you decide to adopt, the final step is one of judgment. In an ideal world you will make a series of comments that are helpful and non-judgmental in nature—but of course human nature being what it is, it has to be admitted that it is difficult at the end of the day to resist the urge to decide whether or not the work being discussed is in your estimation any good at all or not. What to do next is your call. However, if you should make this judgment public, and if you have spent the time following the steps described, should the class erupt in response to your remarks, at least you will be able to defend your conclusions with intelligence, integrity and respect.

It should go without saying that you should also be ready to change your mind should others make convincing arguments to the contrary. *Keep your mind open.*

Above: Advertisement from The Camera. *Philadelphia: The Camera Publishing Company, January 1903. December 1903. Volume 7, Number 12.*

Proceeding without a sense of direction is fraught with peril. However, as the text opposite explains, to establish a direction is relatively easy. It is far better to make this effort than to simply proceed aimlessly. Conversely, do not be a slave to a set of directions of your own making. If you create the road map, you are free to modify it as the journey proceeds. This image is an interpretation of an illustration in Les Mille & un Tours, ou Expériences de Physique Amusante et de Magie Blanche. *ibid. Image by the author, 2005.*

PROGRESSING FROM YEAR TO YEAR

DEVISING A STATEMENT OF INTENTION

In the final year or two of an undergraduate photography course (and all the time in graduate school) one has to accept more responsibility for the nature and scope of one's own growth and development. This can often be a difficult task, especially if the attempt is made to simply delineate a future area of activity in a vacuum. In other words, attempting to proceed without fully understanding the nature and scope (even the meaning) of previous work will most likely sentence you to a fate whereby you simply repeat as many of your mistakes as successes.

The following schema is extremely useful in these circumstances. Although it looks simple, so simple in fact that the temptation may exist to omit the task or to simply perform it mentally, it is of great benefit to allocate an hour or so to complete it in writing. Do not worry whether you might be cutting off choices or otherwise "boxing yourself in." Because the task is self-assigned there is no obligation to follow one's plan to the letter. Quite simply it is a preliminary road map for a future journey, a journey that once undertaken will and must have its own momentum and its own detours, distractions and unanticipated discoveries.

The basic principle of this strategy is to gain from the objectivity that time itself provides. All too often in the rush to finish at the end of the semester the work that is submitted is not fully comprehended. The late nights, the last-minute deci-

sions and the need to "relate" this work to one's intentions all interact in such a way that one tends to look at the work not so much as what it is and what it actually "says" but rather what one would like it to be and like it to "say." However, if this work is put away, even for a few weeks, and then looked at again with fresh eyes, more often than not issues and themes begin to become apparent that previously were quite invisible. The trick, if I can put it that way, is to make these changes in how one perceives one's own work *conscious* and above all, helpful.

Therefore it is worth writing a plan that acknowledges the possibility that one's stated intention(s) at the time of making the work can substantially differ from the effect generated by the finished work. It can be as simple as a page or so consisting of three paragraphs. It is recommended that you start each of the three paragraphs with the following phrases:

All images on this spread are from The Sears, Roebuck and Co. Catalog. *Chicago, IL: 1902.*

Paragraph 1.

When I was making this work it was my intention that it addressed the following issues:

Paragraph 2.

However, now with hindsight and perspective I can see that the work addresses instead (or as well as)
the following issues:

At all times it is extremely helpful to print small copies of some (or all) of the images under discussion and place them appropriately within the text. There is no reason why the Statement of Intention cannot be as beautiful as it is helpful.

Paragraph 3.

Accordingly, in my next body of work I will focus my attention on x, y or z because:

Possible answers might include "I have finished with x and wish to now address y," or "certain themes such as x and y are still unresolved and I intend to expand upon them by doing z," or "the work is good but I have not yet contextualized it adequately. Therefore I will adopt the following approach," etc., etc.

Having done this it is also useful to compile both a visual and a written bibliography. Find examples of other photographers' work that address similar, overlapping or contrasting concerns and include them in your statement of intention. Also quote readings and/or statements that you have found to be useful or relevant.

When you have finished you will have a plan. Because it is your plan, and a response to your work and your concerns, there is no pressure to follow it to the letter. As your work progresses and grows, you are free to modify it at will in response to unanticipated emerging visual and/or conceptual concerns. In fact the more the document needs to be changed or rethought in response to your work, the more likely it is your are following the logic of your vision, not the logic of your conscious, willful mind.

One of the great benefits of constructing and refining an artist statement is that you are compelled to refine your verbal and written skills. Acquiring fluency in using the written word is a valuable skill you will draw upon frequently when you graduate. It is yet one more benefit of the Hidden Curriculum. From The Sears, Roebuck and Co. Catalog. *Chicago, IL: 1927.*

WRITING AN ARTIST STATEMENT

When you present your work it is most likely you will be asked to accompany it with some sort of contextualizing statement. This is usually referred to as an *Artist Statement*. This is a fair and reasonable request. Because of the sheer variety of imaging methods and schools of thought in contemporary photographic practice, it is only right and proper that you intelligently discuss the content and scope of your imagery so others can "locate" this work within the field.

Sometimes this statement is referred to as a *Statement of Intention*. This is extremely problematic terminology as it implies that it is necessary to make the case that what you have done is exactly what you intended to do. Seldom does this occur, and when and if it does it can be more a liability than a success. It is for this reason I subtitled the previous section *Devising a Statement of Intention* to emphasize the distinction between the two. To say it another way, a *Statement of Intention* is forward looking while an *Artist Statement* is a self-evaluation of your work as it stands in the here and now. If anything it is looking back at the process and the work and evaluating your progress, effort and results. More than anything it implies that you understand what you have done.

Confusion arises because constructing such a statement is very similar to devising a future-looking statement (or more correctly, plan). The main difference being that a discussion of future directions is no longer part of the equation. Instead, the task is to "read" your own work, within the context of your intentions, yet be able to simultaneously separate these intentions from the work should it have evolved or even gone off on a completely unanticipated tangent. The more time and thought you give to this process, the more helpful it will be to you and the more satisfying it will be to the audience.

In the first instance consider your intentions. If you have made a *Statement of Intention* before starting this work, as advised earlier, you will have them written down. Retrieve this document and look at the work now that it is complete. Ask yourself:

- In what way have I realized these intentions?
- Where have they varied in response to other issues that emerged as the work progressed?
- Are they still relevant? In response you might find them to be either partially relevant, fully relevant or simply a starting point.
- What is the work actually saying now that it is finished?

Do not forget when doing the above to follow the procedure of *Description* outlined in the section *Analyzing and Reading Photographs*. (See page 25.)

When you have finished then refer to other artists working in a similar vein and/or quote writers and theorists who have also canvassed the issues you too have chosen to explore. This is not difficult and goes a long way to enable others to share both your view of the world and the means you have adopted to communicate it. Sometimes if you possess a distrust of theoretical analysis you may be tempted to say, "the pictures need no explanation." Certainly on very rare occasions this can be the case. However, be aware that this

claim is also a theoretical (and therefore word-based) position, rooted in the modernistic argument that the evidence of the photograph is self-explanatory and needs no contextualizing information. As such, be prepared to defend this position should you decide to adopt it.*

Finally, wherever possible avoid the temptation to adopt arcane language (sometimes known as "artspeak") in order to imbue the work with gravity and authority. Such attempts almost always fail in comparison with a position of candor and honesty. In much the same way one's photographs are always more honest, direct and (usually) successful when you work within your sense of self and with subject matter you know and even love, so too will your statement be more successful if you use your own words, in your own way. This is not, however, a license to be unaware of the field and the work of theoreticians and practitioners whose thoughts and images either dovetail with, or overlap, your work. There is a fine line between deep inner personal conviction expressed in a taciturn manner and naiveté. Rightly or wrongly, naiveté, at least by the end of a formal educational process, equates with ignorance and lack of scholarly effort.

*I attended an excellent conference in Tucson, AZ, during the seventies when I was a graduate student. One of the lectures was given by Ansel Adams. His thesis was that (successful) images do not need to be discussed, or otherwise explained. He argued that they should speak for themselves. I remember at the time asking myself, why then do we need a two-hour-plus lecture to make this point?

Above: From The Camera. *Philadelphia: The Camera Publishing Company, November 1907. Volume 11, Number 12.*

To be surrounded by others engaged in the same task is perhaps the greatest benefit of higher education. Everyday give thanks for this resource. When you graduate, it will be gone. Illustration from The Encyclopedia of Source Illustrations. *ibid.*

OBTAINING FEEDBACK

Perhaps the single biggest, yet most overlooked benefit of higher education is the fact that you are studying in an environment where you are surrounded by other folk engaged in the same task. Perhaps more than the facilities, even more than the teachers, the class itself is an extraordinary asset. Seldom again in life will you have access to such a resource. When you graduate you can pretty much always find a willing and/or helpful friend to share their thoughts with you about your work. However, finding a dozen or so like-minded colleagues to "brainstorm" ideas over the period of a few years is a luxury that will likely never recur in your lifetime.

Never underestimate this resource. Everyday give thanks and participate actively. You will reap great rewards. In particular take advantage of the fact that, especially during assessment, comments made about the work of other students will at some stage most likely apply to you. Pay attention when work other than your own is being discussed if for no other reason than other people's errors and misconceptions are often more clearly perceived than your own. Learn from this.

Also be aware that the nature of the feedback you desire will change over the duration of the course. In the early years the criteria are usually fairly straightforward and often determined by the nature and structure of the course. However, as you progress, and your work starts to take a more individual direction, so too will you desire more individual attention and you will need to initiate a process where this can occur.

This is particularly the case in the final year of undergraduate study and almost always the case at graduate school. In the case of the latter, I have been both a student and have subsequently supervised students at this level. Without exception, graduate students, to hear them talk, no matter where they are enrolled, are in the most unhelpful, disorganized and unsympathetic learning environment in the world. In other words whining and complaining seems to be institutionalized at this level. There are a couple of reasons why this is the case.

In the first instance, because senior study and graduate study is so personalized and so particular to the individual, and indeed so determined by the individual, it can "bear down" on the person concerned in quite an intense manner. This is because the responsibility for the conduct, even the content of the course is yours alone. This can be hard to accept and equally hard to deal with. At this senior level it is your responsibility to motivate yourself, it is your responsibility to seek out feedback if you need it, and it is your responsibility to "use" the class to gain their perceptions of your work. No amount of moaning will release you from this role.

In the second instance, if you genuinely are working at a high level then it may well be the case that even the most talented, knowledgeable and helpful teacher might still not be able to address all of your specific needs. If this is the case you might find it to your advantage to speak with people outside the department or even the school at large. It has been my experience that seeking outside advice is a very useful way to proceed. Whining about "lack of feedback" will get you nowhere.

You will be surprised how often a simple request to a teacher elsewhere with expertise in your area of interest will result in a productive and useful relationship. Often, because there is no formal academic inter-relationship in the background, you will be told things that might never be uttered in a more formal teaching environment. (Be prepared on occasion to silently say, "Ouch!") Portfolio reviews at conferences are another way to get an alternate perspective.

However, you can also overdo this. If you seek feedback from any and every one you meet you may well run the risk of creating more confusion and inner turmoil rather than finding the clarity you seek.

COPING WITH DOUBT

Particularly at the graduate level there will be times when you are genuinely confused and unsure. This happens to everyone at some stage. It is essential however, that you do not permit this to cripple your efforts. You have no choice but to seek advice and act on this advice. In other words, *work* your way through the problem. The more you agonize and worry, the worse things get. Do not compare yourself to others and do not make severe judgments about your own work. The educational process works because sincere efforts are rewarded. Trust this process, work hard, and these fears will evaporate. Procrastinate, agonize and equivocate and you will end up doing nothing, and doing nothing earns only one grade.

To create a thesis is to literally argue a point of view. In the grand cosmic scheme of things, you do not have to be absolutely right. (As if anyone could be!) You simply have to make a case. You can always do something else in the future. It may well seem that sometimes you have to act more bravely than you feel. This is merely one more lesson of the *Hidden Curriculum.*

Below: From The Camera. *Philadelphia: The Camera Publishing Company, November 1918. Volume 17, Number 11.*

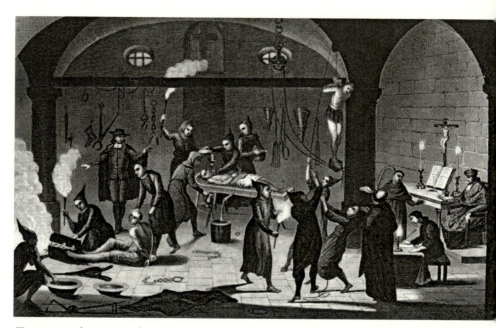

To compare the process of assessment to a Medieval torture chamber is perhaps unfair—although some days it can seem as painful as this. However, if you actively participate and are fully prepared, it should never get quite as bad as the illustration above suggests. From The Encyclopedia of Source Illustrations. *ibid.*

ASSESSMENT

ON TAKING CONTROL

Assessment is often looked upon with dread. However, it is a vital and necessary part of the educational process. More importantly, it is also the occasion when you are most likely to receive the most meaningful responses to your work. As such it is important to approach this part of the process with a positive attitude so you are able to make the most of the feedback you will receive.

One is entitled to be nervous when entering this forum. There is no doubt that judgments will be made both about your work and to an extent, about you yourself. However, the benefits of the process far outweigh the disadvantages particularly if you adopt the attitude that this is a process over which you have a degree of control. There are a number of specific strategies you can adopt to make this happen.

Firstly, think carefully about how you will display your work. If it is to be viewed on a wall then do it with care and attention. Make sure you are happy with how you pin the work up. Is it straight or is it crooked—if the latter, does this help or hinder the message? Is it well illuminated? Is the order of the images correct? Does it look like you care about your work? If it is presented in a folder does it contain a title, your name and any other data in a professional and creative manner? Acknowledge that first impressions, either for better or worse, are often correct!

Secondly, most likely you will be asked to make a short presentation outlining your concerns. The reason for this is simple. These days photographers can pretty much choose to photograph any thing in any way. Consequently, it is incumbent upon the person presenting work to help the audience

to understand just why it is you chose to photograph what you photographed and why you depicted it in the manner chosen. This is why the *Artist Statement* is such a feature of contemporary photographic practice.

Remember also that your body language will communicate as loudly as what you say. Depending on your posture you can easily and unconsciously communicate an attitude of insecurity, arrogance, contempt, indifference and/or disrespect to others in the room.

When the discussion begins it is important to differentiate what comments are about the work and what comments are about you personally. In an ideal world the comments will only be about the work. However, sometimes the comments can be, or can seem to be, personal in nature. Herein lies the rub. It is your responsibility to differentiate between the two. If the comment is personal in nature then simply say, "I think that comment is more about me than the work." This is usually enough to get the dialogue back on track.

However, just as commonly, in fact probably more so, is your own inability to divorce yourself from your work while it is being discussed because of your own fears and prejudices. As such you (mis)interpret valid criticism of the work as being criticism of you. If you allow this to happen you quite simply will not learn about your work, how it is being perceived and "read" by others and how it can be improved as a consequence. You will instead learn how to be defensive, counteraggressive, smug or how to be a good victim. This may feel good in the short term but none of the above do anything for long-term growth either artistically or personally.

Sometimes, however, you can be genuinely and unfairly under attack. It is on these occasions that it is essential to take charge of the situation. This can happen in a number of ways. It usually occurs when the discussion veers from the particular to the general. Sometimes your work will be cursorily viewed, summed up and then a comment made not so much about the "work," as the more general issues it raises. It is very easy to seize upon these generalizations, especially if they "push a but-

ton" by getting close to some of your more basic insecurities, and respond to them in a general way. Alternatively a relatively insignificant aspect of your work can be elevated in the discussion to something of major importance. The moment either of these things occurs the work takes a back seat and the next thing you know the discussion focuses on the debate at hand rather than why it came to be. This is not helpful for either the artist or the audience.

There is one thing you can do if this looks like this is happening—especially if you feel threatened. After taking a deep breath, you must ask the person making the comment to show you exactly what it is in the work that prompted that comment. If you do this, the discussion will then re-focus on the images. Subsequently, the validity of the comment will be tested against the perceptual data (the photographs) that presumably prompted the remark. It is surprising how often this direct comparison between the comment and the stimulus can result in a new understanding for all of the participants— almost always in a most positive manner.

Additionally, everyone will at one stage encounter someone who believes their opinions and prejudices are statements of fact. This can often be a bully, or at least a blusterer, and this can be difficult to deal with, especially if you are not outgoing or combative by nature. There is only one thing to do. State that you believe that the comment is a valid opinion but not necessarily a valid criticism. After that it is every man and woman for him—or herself! Some days you might win, some days you might lose.

Right: Image from an advertisement in The Camera. *Philadelphia: The Camera Publishing Company, November 1907. Volume 11, Number 12.*

Finally, the most painful feedback of all is when someone else is right! Most often this occurs when you genuinely miss some aspect of your work that is glaringly apparent to others but for some mysterious reason, you simply cannot see. In practical terms this is most apparent when there is an enormous gulf between what you say in words and what your images are saying visually. This disconnect happens surprisingly frequently. Most often this occurs as a function of mistaking intention for effect—in other words insisting that your images are about what you want them to be about and not recognizing what they are actually saying. When and if this is pointed out, you have no course of action available other than to acknowledge this discrepancy and work on reconciling the gap next time around.

In conclusion it should be apparent that there is much that the person being assessed can do to make the process engaging, enriching and helpful. Inevitably, at some stage feelings will be hurt and injustices will occur. This can never change. However, with mutual respect, sensitivity and care, the frequency of such events can be kept to a minimum.

However, no artist should ever shrink from rigor and the sometimes painful criticism assessment requires. Even so-called personal criticism is appropriate if you have in fact been lazy or disorganized.

Such things come with the territory.

Above: From The Encyclopedia
of Source Illustrations. *op.cit.*

Sometimes the process of higher education feels like a game of Snakes and Ladders. That's because, just like life, it is! Snakes and Ladders, Kismet, UK 1895. *Victoria and Albert Museum of Childhood no. Misc. 423-1981.*

ACADEMIC HONESTY AND COURTESY

Over the years I have had one or two students try to "fool" me in this manner. The most spectacular occasion being when one student actually stole prints that were made by another student out of my own storage cabinet (they were left there for "safekeeping") and try to pass them off as his own! Most people are neither this brazen, or to put it more bluntly, this arrogant and stupid. (If you are wondering, he failed the course and was suspended from the college for a year.) More often the offenses are subtler, and to be fair are sometimes due to simple carelessness. No matter what, the practice destroys trust within the class and undermines that most precious quality of higher education: which is the desire on everybody's part to create and maintain as fair, open and joyous an atmosphere as possible.

PLAGIARISM

Plagiarism is to copy or imitate the language, ideas or thoughts of another author or artist and pass it off as one's original work. It should go without saying that this practice is completely unacceptable in any circumstance but is even more egregious in an academic environment. Not only that, it is completely counter-productive. It is quite simply a waste of time and money to attend a college and fail to avail yourself of the opportunity to develop and refine your own creativity and sense of self worth—neither of which can be accomplished by stealing the efforts of others.

At the simplest level, plagiarism, if even suspected, can seriously erode your relationship with your instructor. From his or her perspective, they will assume that you think they are a fool. Nobody likes this sensation. More to the point, if it should be proved you have been engaging in this practice you run the very real risk of being at minimum failed, more likely expelled from the class and in certain cases expelled or suspended from the institution as a whole. You will also feel awful—as will your teacher and your classmates.

There are occasions however, when is it legitimate and appropriate to incorporate images from outside sources. This is quite different from plagiarism as the intent is not to deceive, but to comment or even satirize. This mostly occurs if you collage images from a variety of sources or wish to simply and legitimately comment on the barrage of images and correlates of "corporate image" that bombards us daily. Such uses are, at least in my opinion, quite appropriate. However, the "owners" of such images (assuming the images you have used

are not in the public domain) might not share this view and if you intend to publish the pictures in a very public manner the threat of a lawsuit is always in the background. There are no hard and fast rules and decisions have to be made on a case-by-case basis. Certainly satire and fair usage are a defense but if the argument has to be made in a court of law, it can also be an expensive defense. Be careful! (See pages 94–97.)

Within the academic community you can protect yourself to a degree (at least from charges of plagiarism) by acknowl-edging your sources. However, the difficulty is that the visual arts have neither a history of, nor a formal procedure for, so doing. Unlike a written thesis, where the more you show the extent of your reading by including properly attributed quotes and summaries of arguments the better, in the visual arts, this can somehow seen like cheating. However, these days the art-ist statement is an almost mandatory accompaniment for most works of visual art and if you have any doubts you can use this forum to attribute your sources. There is no shame in this for we all stand on the shoulders of giants. However, outside of the academic community in the world of profit and property, even such attention to scholarship and good manners may not protect you from a zealous corporate lawyer.

CAMERA ETIQUETTE

Using a camera, particularly when documenting minority groups, other cultures or those obviously less fortunate or simply "different" to ourselves should be approached with cau-tion and a sense of responsibility. The history of the medium is replete with many examples of how the camera can objectify (and/or consciously or unconsciously denigrate) the subject of its relentless gaze. Many years ago I wrote a story about this less admirable use of the medium. I have lost the original but it went vaguely like the following. It is a little harsh—but far less so than using a camera without any respect for, or under-standing of, your subject

Above: From The Camera. *Philadelphia: The Camera Publishing Company, November 1907. Volume 11, Number 12.*

There was once a photographer who had the wonderful luck to find a homeless person of great visual interest. He could be found sitting on the same park bench everyday, rain or shine. His ruffled appearance and deeply lined face were ideal for showing all manner of things, many of which the photographer thought of as being profound and of universal value. Suffering, sadness, nobility in the face of adversity were just some of the lofty themes he imposed on his images. These inspired many grandiose titles that he wrote on the mount-board of his carefully crafted exhibition prints with a flowery hand.

He won many awards for his images and his colleagues were both jealous of his success and curious about his subject. They begged him to show them where they too could find this wonderful model. For a time he was able to deflect their insistent enquiries but eventually he relented and agreed to lead them to the park bench where he knew the man would be.

It was a Saturday morning—a perfect autumn day. Occasional clouds scudded speedily through the otherwise crystal clear sky. They all met at the corner of the park and carefully checked their equipment—lenses clean, plenty of fresh film in the camera, tripods at the ready. The photographer led the group to the park bench where the man could always be found—but the bench was empty.

His friends began to laugh and jeer. They called him a fraud and a con man and they left him alone in the park, their parting words and laughter echoing in his ears. He was furious and deeply embarrassed by all that had just happened. He resolved to return the next day to tell this guy a thing or two.

However, the park bench remained empty for an entire week. The photographer vaguely knew the whereabouts of a homeless people's shelter. He found it a mile or so from the bench in a narrow, grimy street set back a few blocks from the other side of the park. He asked the attendant about an older man with regular habits.

"You must mean Aldus," the attendant replied. "He died two days ago. His funeral is this morning."

The photographer raced to the cemetery. He arrived as the first few clods of earth drummed on the plain boxwood coffin. He raised his camera to his eye and clicked the shutter. The resulting print was excellent. He titled it *Time*. It was his finest work and it won many medals and awards.

Ten years went by. Yet another homeless person had claimed the very same park bench as his own. Ignoring the looks of pity and contempt of the passers-by, he sipped at the promise of oblivion in the brown paper bag. Although from the outside he appeared calm, in his mind he replayed again and again the sequence of events that led to him being there.

Meanwhile, in another part of town, a young art student who had been surreptitiously photographing this man for the past few weeks showed his girlfriend his latest prints.

"Who is this guy?" she asked.

"I don't know," he replied. "He just sits there all day, every day. Occasionally though he will cry out the same thing in the most unexpected way. I haven't been able to capture that exact moment yet."

"What does he say?" she asked.

"I'm not sure if it's even a word. It just sounds like pain. If I had to guess, it sounds like he is saying 'All dust.'"

PROCEDURES

In simple terms, "Be patient, tolerant, kind, compassionate and respectful."* This will take care of most problems. However, be aware there are also legal issues to consider.

1. Photographing inappropriately, especially in a public place, can result in being cited for "creating a nuisance."
2. Pictures taken "in private" in someone's home for example, may generally not be published without written permission.
3. Obtain a model release whenever there is any doubt.
4. Libel can be committed with a photograph.
5. Invasion of privacy, while similar to libel, is not the same thing, and unlike libel, truth is not a defense.

*From Photography for Perverts. *Oakland, CA: Greenery Press, 2003. Charles Gatewood, a tireless and prolific photographer of the underbelly of society, gives advice for those interested in photographing sub-cultures while remaining ethically intact and lawfully protected. His book is for adults over 18 years.*

6. In a post-9/11 world, photographing pretty much any thing, especially at odd times of day or night, can result at minimum in a few frightening minutes with authorities who (not unreasonably these days) want to know what you are doing. Get a letter from your Department Head if you wish to photograph in places that could seem to be a place of threat, e.g., train yards, highway structures, etc. This will not offer total protection but will certainly help to verify your presence and intent. Stay cool and polite if so intercepted.

FINAL THOUGHTS

While describing "allthethingsthatcangowrong" I cannot help but reflect on the nature and ultimate function of the visual arts in general and photography in particular. Consider the Commandment expressed in Exodus 20:4:

> Thou shalt not make unto thee any graven image, or any
> likeness of any thing that is in heaven above, or that is in
> the earth beneath, or that is in the water under the earth.

As a visual artist, I frequently wonder why this commandment is so precisely expressed but so routinely ignored. I have been told that the intention of this commandment is to forbid idolatry. Yet this is not what is written. Possibly it anticipated a time when the world would float on a tide of superfluous, cynical and commercial images whose only function is to promote greed, desire, and ultimately much unhappiness. Perhaps God in his wisdom tried to prevent this from occurring.

Looked at in this light, perhaps all imagery is idolatrous, and all artists (especially photographers) are de facto theologians creating false gods. The consequences for achieving any coherency of belief are profound. The very real possibility exists that we now have as many gods as there are pictures and as many preachers as there are artists. I sincerely hope this is not the case. However, it does explain a lot of otherwise perplexing phenomena.°

° Final Thoughts *from the author's monograph,* Veronica. *Rochester, NY: Clarellen, 2006.*

Above: Do not do to yourself that which you do not like others doing to you. If you do there is only one place you will end up! Self Evident. *Image by the author, 2006.*

SELF-LIMITING TALK

Watch any news program and you will hear the anchor person ask how that war, natural-disaster, plague, famine, etc., "story" is proceeding. No longer do they use the words "report" or "account." Everything is a story. If I had just watched my parents drown or be injured or killed in a bomb blast then I would prefer that the record of this event be as accurate and as related to real life as possible. The thought that this event might just be a "story" in someone else's universe would be too painful to contemplate. Yet this terminology is ubiquitous. Its cumulative effect is to demean the suffering of others and to undermine trust within our society.

Many of the biggest inhibitors of growth are self-imposed. For example, how often does one hear people say, "I am a photographer and therefore cannot write?" Conversely, one often hears poets and writers say much the same thing about the visual arts. As often as not, this is simply untrue. Instead it is the perpetuation of a pernicious notion that insinuates itself into our minds that we are only allowed to be good at one thing.

In a way this is true in the sense that if we spend a lot of time practicing one art form then slowly we develop a sense of competence and confidence in our efforts and are less inclined to inhibit risk-taking behavior or be afraid of attempting new things. However, it does not follow that we cannot do something else in another medium. It simply means that it is more difficult because of this lack of groundwork and experience. It does not mean that the task is impossible, nor does it mean that there are two different kinds of mutually exclusive intellectual skill sets. More often than not it is a matter of jumping off a one-foot-high cliff—a cliff that before you jump appears to be enormous—but when a microsecond later you land safely, you can only wonder at the strength of the fear that you created in your mind.

Not only that, at a more prosaic level you will restrict employment options upon graduation. I remember at a conference in New Mexico in 2005 a photographer who had worked for most of his career for *Time* and *Life* magazines, told us great stories of the good old days when the magazine would send a team of people to gather the "story."* There would be a writer, a photographer and some kind of editor dispatched.

He compared this with current practice where commonly news journalists these days write the report, make the photographs, write the captions for the photographs and obtain all the necessary releases from the subjects they photograph. Not much room here for someone who "doesn't do" all of those things!

It is one thing to do this with a new and very different task like writing, but it also happens surprisingly frequently with respect to choices within the medium itself. Beware of any sentence that starts along the lines of "I don't/can't do X, Y or Z." (For example, "I don't do color!") Almost invariably you will limit the range of possibilities open to you and equally, you will be wrong. It is difficult to ascertain where such self-limiting behavior originates. Is it a result of a casual remark made by a teacher or classmate? Is it a function of halfheartedly trying something and falling short on the first attempt? Is it a conceit picked up by either hearing or reading what someone else has said? Any or all of these could be the case, but in any case, the net result is a self-imposed limitation that can seriously hamper one's growth.

Both images on this spread are from The Sears, Roebuck and Co. Catalog. *Chicago, IL: 1902.*

I had a friend and colleague in Australia who had a term for this phenomenon. He called it "P.S.E." This was an acronym for *Premature Stylistic Enclosure*. He, like myself, was shocked at how often a first or second–year student could make such broad-brushed pronouncements with such conviction and bravado.

Wherever possible avoid this kind of statement. If you find yourself saying such things, pause for a moment and attempt to discover the origin of this perception. It may well be nothing more than a seemingly harmless excuse offered on the spur of the moment. However, once said such comments often become de-facto statements of intention and the irony is that even though untrue, from that moment on, you really can't do what you said you couldn't do.

*During your course of study you will be given many in-
structions and asked to conform to many rules. You may
feel at times that you are being cramped or otherwise
hedged in. However, none of these external pressures
will in anyway cramp your style more than the restric-
tions, rules and limits that you apply to yourself. These
are the most pernicious and long-lasting of all. Don't
make a box for yourself.*

EXCUSES 101

I am not sure whether the following is true, or whether it is just a dream, but it seems that a long time ago I had a student we will call Z. One day she arrived (again) late to class without any work. She explained that the reason for this was that the night before she was feeling depressed and decided to get a razor and slash at her wrists. Having done so she had second thoughts about the wisdom of this action and hopped into her car to drive to the hospital. On her way she rolled her automobile. When the police arrived at the scene they found a small quantity of marijuana in the glove compartment. As a result she was apprehended, taken to the police station for a couple of hours before ending up at the hospital. Consequently she was up all night and was unable to finish her work!

Whether any or all of this was true or not I will never know for sure. But I do know the bandages on her wrist disappeared by the next class two days later—leaving no scars.

However, more than anything, it established a pretty impressive benchmark for excuses. I suggest offering anything less than this level of complexity (and most likely imagination) is not likely to work as hoped. Essentially what I am proposing is that excuses be graded in much the same way that other work for class is graded. I would (and did) give the above a mark of 9 out of 10. I would suggest that anything less than an 8 be disregarded out of hand.

Left: Image from The Sears, Roebuck and Co. Catalog. *Chicago, IL: 1927.*

Overleaf: All images from The Sears, Roebuck and Co. Catalog. *Chicago, IL: 1927, with the exception of Item 13, which is from* The Camera. *Philadelphia: The Camera Publishing Company, November 1903. Volume 7, Number 1.*

Surprisingly frequently a student will pin his or her prints on the wall and preface any accompanying remarks with the words, "This was just an experiment." These words, when decoded usually mean something like this:

> I took these images with no real plan (and to be honest with no real thought) and therefore I show them to you while assuming no responsibility for their worth or otherwise. As such do not criticize me excessively as I don't quite yet know what I am doing or have done.

The trouble with this excuse is that it abdicates personal responsibility and even worse, devalues an empirical approach that, if taken seriously and responsibly, can produce work of great (and unexpected) beauty.

Imagine how different the world would be if Alexander Fleming after looking at the shabby patches of grunge in his little petri dishes and decrying the failure of his initial experiment, simply tossed the penicillin mould in the trash. Fleming was not looking for antibiotics— he was presented with this discovery as a result of his search for something else—and he had the choice to see or not see this new material. His medium was the scientific empirical approach, his outcome the result of interacting with that medium. He took the answers he received—even those generated by accident—as valid data and as a result made a ground-breaking discovery.

Thus instead of using the phrase "just an experiment"* as a buffer against criticism, see it instead as a legitimate way of generating imagery, with the proviso that the data so generated be scrutinized with intelligence and receptivity.

*Note: "Just" can mean "appropriate and correct" as well as "merely."

TYPES OF STUDENTS

1. The Feedback Junkie. Requires constant feedback and/or reassurance.

2. The Seeker of The Secret. The student who thinks that the teacher is with-holding information that, if only divulged, will guarantee success.

3. The Pleaser. The student who wants to be told exactly what to do.

4. The "Organized" One. A student who is juggling too many things, e.g., an external job, family and/or other obligations, in too little time and expects the class to accommodate this self-imposed regime of near panic.

5. The Praise/Approval Seeker. One seeking validation of mediocre efforts (often already produced).

6. The Eternally Disappointed One. Always wants his/her work to be something it isn't.

7. The Macho Man (make that Boy)! Thinks making art (or taking one's feelings and thoughts seriously) is for girly men.

8. The Slow (sometimes sporadic) Developer.
 Not necessarily a bad thing.

9. The Consistent One. Not necessarily a good thing.

10. The Abdicator. Expects the teacher to "motivate" them.

11. The Victim. Uses illness, misfortune, ethnicity, etc.,
 as a substitute for work.

12. The Rebel. The student who insists on doing/saying the
 opposite no matter what the issue.

13. The Lazy One.

14. The Worker. Heaven!

If you are by nature modest in temperament, you may find it uncomfortable at first to "blow your own horn" in too strident a manner. However, it is not asking too much to simply have sufficient respect for the viewer of your images, who may well be a future employer or graduate school admissions officer, and present your work professionally and appropriately. This is not ego. This is common sense. Image from The Sears, Roebuck and Co. Catalog. *Chicago, IL: 1902.*

ASPECTS OF PROFESSIONAL PRACTICE

When you graduate you will want or need a job, and/or a show or further education at the graduate level. To satisfy this need you already have, and will also need, the following:

1. You will have a formal degree that certifies that you have successfully negotiated the program.
2. You will have a transcript that will show what courses you took and the grades you earned for each course.
3. You will need references from one or more faculty.
4. You will need a curriculum vitae (resume).
5. You will need to write a letter of application.
6. Ideally you will have a website or an online portfolio.
7. You will have your work.

1. The Degree

Employers will look at the degree primarily from the perspective that it certifies that you can be trusted to complete a set task within a structured environment. It shows that you are capable of working under supervision and that you respect both deadlines and authority.

2. The Transcript

This will be primarily of interest if you are seeking to enroll in a graduate course of study or wish to get a job in a college or university. Naturally the greater number of good grades you have the better because grades are the currency of universities. However, even if the record is not ideal, there is always hope as we will see when we come to Item 7.

3. References

These are crucial. Gaining support and having it substantiated in writing, especially in a relatively small arena like the photo-community (where most people either know or know of each other) can greatly help your chances of success. Almost always there will be one instructor with whom you have forged some kind of bond and will support your application. Try to avoid putting yourself in a position where your reference resembles the following example.

> Dear Search Committee Chair,
>
> I am writing this letter for Mr. John Smith who has applied for a position in your department. I should start by saying that I cannot recommend him too highly. In fact, there is no other student with whom I can adequately compare him, and I am sure that the amount of mathematics he knows will surprise you.
>
> His dissertation is the sort of work you don't expect to see these days. It definitely demonstrates his complete capabilities.
>
> In closing, let me say that you will be fortunate if you can get him to work for you.
>
> Sincerely
>
> A. D. Visor (Prof.)*

4. Resume

You will also need a Curriculum Vitae. This is where the more positive aspects of the *Hidden Curriculum* shine. If you have been a good student you no doubt will have participated in many activities outside of the classroom. You may have had individual or group shows with your classmates. You may have even helped organize these shows. Any activity you engaged in that connected the school to the community is well worth mentioning. Have any of your pictures been used either by the school or by the local paper? Once you start to list these activities you will be surprised how many you have done, and how helpful they have been, even though at the time they might have been seen to be incidental to your studies.

** I made several attempts to track down the author of this parody. I have seen it reproduced in two separate journals. I contacted the editors of both and they had no idea who wrote it. Accordingly, I deemed it safe to reproduce it here. Should anyone know the author, or more wonderfully, should the actual author see this, then please contact me so I can properly attribute it in the next edition.*

Above: Wherever possible, avoid putting your foot in your mouth. It is hard to walk the fine line when so handicapped. Image from The Sears, Roebuck and Co. Catalog. *Chicago, IL: 1902.*

5.(a) Letter of Application for a Job

The Letter of Application must address the published criteria for the position. Usually a job description will have mandatory requirements and optional requirements. It is important to read the description carefully to distinguish between the two. The mandatory requirements are non-negotiable. If it says you must have a Master's Degree, then indeed you must. However, the optional requirements are more open to negotiation and/ or interpretation so do not be put off if you genuinely believe you can learn new skills and adapt to new directions. In your letter say how your current knowledge and experience dovetails with or can be adapted to the advertised position. As a general rule less is better than more. A page is usually enough.

5.(b) Letter of Application for Further Study

The Letter of Application for further study is a lot more open than one for a job. The graduate school will want to know not only how well you have worked in the past, but also whether you are capable of working in an independent manner, and that you have some sense of your future direction. If you dwell too long on your successes to date, and refine the work to an extremely high degree, in a perverse way this can work against you as it can look like you have closed off any possibility for future growth by presenting an almost hermetically sealed fait accompli. It is worth re-reading the essay on *Progressing from Year to Year.* (See page 47.) Consider adapting it to form part of your application. In this way you will be seen as addressing the future of your work and not just promoting your past successes.

6. Website

Things have got to the point where this is virtually mandatory. See further remarks in *The Initial Application* overleaf.

7. Your Work

Apart from your manner and appearance at an interview, the quality and presentation of your work will be the crucial variable when decisions are made about whether to admit you to graduate school or give you a job or a show. It is also the factor over which you have the most control in the present tense. The first three items are fixed in the sense they are things that have been put in place over the last few years. Your work and the way it presents, however, is something you can attend to now. The main issue to consider is coherency of presentation. There are two stages:

THE INITIAL APPLICATION

In the not too distant past the standard way to communicate at a distance the nature and form of your work was to send 35mm slides. Seldom however are they asked for anymore. Usually electronic files, primarily written to CD ROM, are the medium of choice. In many cases the technical specifications will be stipulated in the job posting so you must do as requested. Generally speaking PDF documents are almost always acceptable and are easy to construct. They offer a great opportunity to present your work coherently in the sense that you can put your images into a single document and thus control their appearance on the screen, the order in which they are viewed and also insert text so that they become a self-contained visual experience that is easily navigated by the viewer. This is far preferable to including a folder of individual image files that the viewer has to open one by one.

Above: Detailed instructions for editing and presenting your images can be found in the author's companion volume Photo-Editing and Presentation. *Rochester, NY: Clarellen, 2009.*

These documents are best made from a page-layout program such as InDesign, which permits you to include text and images and then write the finished work to a PDF file. However, even MS Word can permit you to craft quite elegant documents that may also be written as a PDF file if you do not have access to, or knowledge of, InDesign or QuarkXPress.

If you do not wish to create the more linear, book-like experience associated with such programs you may instead decide to offer an interface with multi-path links to various sections and categories along the lines of website design. In either case the CD should open on any machine or platform, the relevant file be clearly apparent to the user, and the navigation be as simple and self evident as possible.

Having gone to this trouble it is not that much extra work to employ the material to create your own website. Alternatively, you may consider posting material on one of the many sites available online.

AT INTERVIEW OR
WHEN SENDING ORIGINAL MATERIAL

To an extent the way you present your materials at interview is a function of the job you are seeking. If it is a commercial position then pre-fabricated albums are often appropriate. There are many different types available and some made of quite beautiful material such as Plexiglas and even metal. If however, you are applying for an exhibition, an academic position or to graduate school, then as a general rule anything pre-fabricated is not a good idea.

These latter institutions will evaluate your work as a manifestation of yourself and your values. Attention to detail is essential—this even extends to the most prosaic aspects of your presentation. Therefore try to have a coherent style with respect to the way you organize your materials and ideally relate this style to the way you presented your initial application. Do not, as a general rule, mix a variety of typefaces in any supporting written material. Keep things clean and consistent (or grungy and consistent). A good sign of success is if someone remarks, "Oh yes, I remember your application" the moment they see your work.

In *Digital Book Design and Publishing* the comment was made that "good presentation is a mark of respect for the viewer of your work. It is an act of generosity and giving. It

should say to the reader that he or she is invited to view the work, and that his or her opinion is valued and respected.

It is important to remember that you are always making a statement, whether you like it or not. When you show someone your work, you should be saying, "This is my work, I take it seriously and I have considered all of the aspects of its creation and presentation, and I would like you to take the time to read and appreciate it."

Do not allow it to imply you did not think through all the issues sufficiently. You may as well be saying, "Here is my work, take it or leave it. Really, I don't care what you think!"*

This may seem like hyperbole. However, appreciate that your final touches are another's first impression. As such consider carefully the way you "house" your work. Is it best seen in book form or is it more appropriate to either buy, or preferably construct, a portfolio case to hold all of the material.

It may be that you have a variety of examples of work. You may have a book or two, some prints and installation views of previous exhibitions. Try to conceive of ways to "package" these disparate elements within a suitable box or portfolio case so that your materials are easily accessible. Just as importantly, consider how you can re-pack your work in a professional manner and in the shortest possible period of time. The most successful interview can come completely undone if at the end you find yourself struggling to put everything away in a clumsy and ungainly manner in front of an increasingly impatient and judgmental audience.

Consider also the appearance, nature and tactility of the total experience. A box covered with shiny black book-cloth will convey a completely different impression than a box covered with raw canvas. Either can be good, but each will have a different effect on how your work is perceived. No impression is necessarily "better" than any other. The material should be chosen on the basis of what is appropriate to the nature of your work and the message you are trying to convey. However, in all cases your levels of craft should be of the highest order and appropriate to the content of your work.

*See the author's book, Digital Book Design and Publishing. *Rochester, NY: Clarellen, 2001.*

Opposite page: Although one can purchase quite serviceable portfolio boxes from a variety of supply houses, nothing quite compares with making a portfolio case from scratch. In this way you can choose materials that harmonize with the images. The portfolio box opposite is made with the same canvas that is depicted in the image inside. These two images are excerpted from the author's companion volume, Photo-Editing and Presentation. *op.cit.*

Finally, almost always you will be asked to provide some kind of statement that reflects your understanding of your work. Wherever possible integrate this statement into the presentation of the work itself so it is seen as part of the totality of the work and not as an adjunct or afterthought. In simple terms consider presenting the statement in the same size, shape, and style of the work to which it refers. Thus if presenting work in portfolio form, the statement should ideally be printed on the same substrate in a sympathetic manner. If your work is presented in book form, then the statement ideally forms part of the content of the work and will be bound into the book as part of its content

In conclusion, always remember that your work, and the way it is presented, will more than any other factor influence your success or failure. Thoughtful, well-executed work sensitively and appropriately presented will be retained in the mind of the viewer long after the references have been read and the transcripts evaluated. If you have had mishaps in the past and have received poor grades or even failed a course or two you can be redeemed if your work shows you have learned from these experiences and above all, now care about your work and your future. Conversely, even if you have a good academic record, if your work is presented in such a manner that it conveys the impression that you do not care about either it or the way it is received, you may well not receive the success and approbation you seek or hitherto earned.

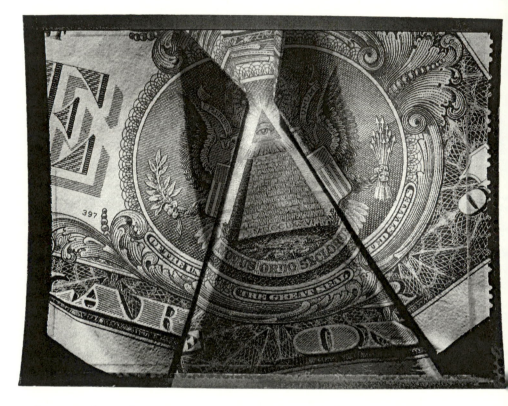

When issues of copyright intrude into your work you are suddenly dealing with two serious entities, the authority of the law and the power of money. As such be very cautious and respectful. No Title. *Image by the author. 1990.*

COMPUTERS, COPYRIGHT AND THE LAW

This chapter is adapted from author's book, Digital Book Design and Publishing. *Rochester, NY: Clarellen, 2001.*

** http://www.openculture.com/2009/11/lawrence_lessig_speaks_once_again_about_copyright_and_creativity.html*

In this chapter some of the issues surrounding contemporary digital practice will be discussed and debated. It is based on an essay I wrote on this topic in 2000. It outlines a very cautious approach to the problem and the issues of copyright. There is no doubt that if you follow the advice in this first section, you will keep out of trouble. However, copyright law is based on 19th and 20th–century conceptions of tangible property and analog forms of copying. In this virtual age, new technology has created new practices that are so ubiquitous that we find ourselves in a situation that, according to Lawrence Lessig,* criminalizes almost the entire population of the United States, or if not the whole country, almost certainly anyone under the age of 30.

COPYRIGHT

The ability of the computer to render any information in a discrete code and subsequently process, amalgamate, modify, transform and re-present this information makes it the ideal medium for a postmodern world. These attributes, however, make it easy for the individual to access the intellectual property of others to the point where the boundary between fair usage and plagiarism becomes blurred and difficult to differentiate.

This can occur at a number of levels and in a variety of media. The rights of visual artists, once protected by the skill required to practice their craft, are now easily appropriated by anyone with image-processing software. On a more prosaic level, the ability to cut and paste text removes the drudgery of copying quotations and makes it possible for an individual to create an essay entirely from a pastiche of the words and thoughts of others.

Looking at the positive side, such possibilities suggest that knowledge may grow and become more complex as new ways of integrating data facilitate new connections and reveal unexpected and interesting juxtapositions. The downside is that such practices can erode the concept of originality and scholarship, turning the individual into another kind of box, much like the computer itself, able only to function as an editor of an endless loop of second-hand thoughts.

Ultimately it is the individual who must take responsibility for the way he or she uses the computer. As with most things in life, if it feels wrong then it most likely is. This guiding principle will prevent most problems from occurring. However, there are some practices that seem harmless because they are relatively commonplace. Protestations of "everybody does it" will be of little use if the individual finds him—or herself in a position where a software company or another individual decide to exercise their rights to protect their property.

Many of these problems arise because activities that were once relatively self-limiting in the analog world of objects, things and complex mechanical processes have actually changed both in character and ease of production in the digital domain.

THE PROBLEMATICAL NATURE OF COMPUTERS

The Ability to Make an Identical Copy

Until the advent of digital technology, to make a copy was to create an object that differed from the original item. However, it is now possible to make an unlimited number of identical copies of anything that appears on the computer screen. The code that represents an image, document or piece of software can be copied an infinite number of times and in each case the copy is exactly the same as the original.

There are many implications for practice as a result. Perhaps the most seductive notion, and the one that is most likely

to cause an individual to commit an offense, is the notion that there is no actual theft of an object, only a copy has been made. However, whether the original string of code represented a computer program or utility, an image or a written document, each (digital) copy has the same qualities as the original. This is a significant change from analog practice.

For example, one can theoretically make an infinite number of prints from a single photographic negative. In practice, however, variations are inevitable as the negative is translated into print. Changes in paper stock, temperature variations of the developer, deterioration of the chemicals and a host of other variables all combine to make it extremely difficult to make an edition where each print exhibits identical properties. Additionally, the negative itself, with repeated use, can become scratched or otherwise altered. The problem is exacerbated if the negative is duplicated, either from the negative itself, or through the fabrication of a copy negative made from a print. As each generation is created so is there an accompanying drop in the quality of the image.

In comparison, digital code, no matter how many times it is copied, remains the same, irrespective of how it is recorded. Unlike the vagaries of photographic paper or other analog forms of media, the carrier of the code exerts no influence on the content of the digital document. Whether one uses a cheap memory stick or a gold-plated CD ROM, the media has no effect on the contents other than its mechanical reliability in the machine. The code remains the same.

There are a number of implications for the individual, all of which conspire to lessen the apparent seriousness of the activity.

It is no longer necessary to possess the "original." One does not have to physically steal an object when a copy will function just as well.

As discussed above, each copy of a digital file is an exact clone of its "parent." Thus a copy of a digital file has the same quali-

ties, and value, as the original. A common rationalization is that "nothing has been taken, but simply a copy has been made." However, such a defense is inappropriate with respect to digital files where the copy and the original are indistinguishable from each other.

The Cost of Making a Copy is Low.

All that is required to infringe copyright in the digital domain is a personal computer and some type of storage device. As such the act of infringing copyright of digital files carries with it little economic investment. This lack of a financial barrier minimizes the apparent seriousness of the infringement. The offense seems minimal if not trivial. Can a ten-cent CD suddenly become worth hundreds, even thousands, of dollars?

The Ease of Making a Copy.

Because a digital file can be easily copied, this process contributes to perceiving this act as relatively harmless in nature.

The Homogenization of Physical and Intellectual Property.

Computers are capable of re-presenting and representing data from all media in a uniform manner. Through the process of digitization, where conventional analog forms of knowledge are converted into mathematical equivalents, it is possible to reduce the particular qualities of otherwise quite disparate media into a single uniform format. The sound of a musical instrument, a painting, a photograph, a book of poetry or scientific theories, can all be rendered in the same digital language.

There is no discrimination in terms of qualitative worth. This process subtly suggests that all information is of equal value or equal non-value. Great works and small, masterpieces and doodles, the efforts of both the master and the apprentice, all are reduced to the same format, and may be transmitted and stored in the same way.

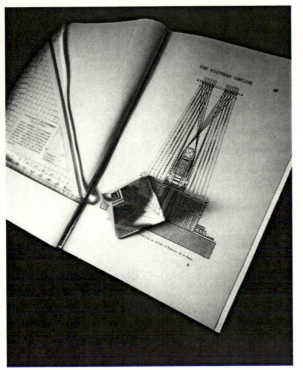

Above: The Minor Monument. *Image by the author. 1992.*

This has the ability to engender a position of moral confusion. Data becomes data becomes Dada (read nonsense). When everything can be seen to be the same, then all things come to assume equal value.

It is thus very easy to adopt and maintain the perception that all knowledge stored and transmitted on electronic delivery systems is a kind of intellectual smorgasbord, free for the taking. There is nothing intrinsic to the process that makes it self-evident that one set of code is free and another must be paid for. The digital world has no sense of reality, nor does it discriminate between expensive and cheap, exotic or familiar. Unlike previous publishing and artistic practice, digital code cannot distinguish itself through its appearance and quality.

The Lack of a Hierarchical Structure of Skill Acquisition.

Within the computer domain itself, once the basic skills have been learned then one quite quickly gets to the point where doing something sophisticated requires only a little more skill than doing something simple. When one learns to scan an image, or download something from the web, then the skill is learned. What you then choose to scan or sample is simple repetition. Compare this to past practice when if you wanted to forge a painting, or a dollar bill, you had to acquire almost as much skill as the person that made the original object. It took years of practice to acquire the skills to be able to be a forger. Now with a scanner and a printer anyone can make a facsimile of almost anything. Do not be a thief or a forger.

SOFTWARE COPYRIGHT

Because of the ability to make an exact clone of digital code, it is very tempting to simply copy a piece of software. This is particularly the case when the software is expensive. Not only is this illegal, it is also extremely disrespectful to the creative people who devised and refined this software. It is enough to say that copying software is illegal and the penalties can be severe. A software company might decide to pursue the matter in court. If you are enrolled as a student, it can result in you being suspended or expelled from the school.

It is also much easier to get caught than you might think. Be aware that if you are connected to an Ethernet network, then the network manager can, at any time, from the comfort of his or her office, search the entire contents of your computer and identify suspicious software.

TEXT COPYRIGHT

The laws concerning the copyright of text have been little changed by the digital revolution. The use of small quotations and properly attributed ideas was, is and will likely continue to be, permitted.

What has changed however, is the ready availability of vast amounts of information on the Internet that can be quickly and easily copied and pasted into an essay or text. This activity can seem less like plagiarism because of the sheer volume of information on the net, and the quite often idiosyncratic way it is presented and "published."

However, quite simply it is wrong, and illegal, to use the work of others without attributing the source. It is worse to do so using large slabs of text that pose as your own individual thoughts. If nothing else your work will not be yours at all.

The images on this spread are from
The Sears, Roebuck and Co. Catalog. *Chicago, IL: 1902.*

IMAGE COPYRIGHT

For the digital visual artist, this is perhaps the most contentious area of all. The problem is particularly exacerbated by a prevailing visual aesthetic that encourages and promotes photo assemblages and collages. This aesthetic is a direct function of the computer's ability to cut and paste with seamless precision. William Mitchell* makes the point that in the past collages remained a fringe activity in photography because they were "usually technically difficult, time consuming and easily detectable." This however, is no longer the case. As mentioned earlier, the traditional notion of skill hierarchy has been largely eroded by the computer. Now even a novice can, with some success, graft a number of visual sources together to create a photo-collage.

Mitchell, W. J. The Reconfigured Eye. Cambridge, MA: MIT Press, 1994.

The Internet is full of images waiting to be downloaded. Their access is so immediate and so simple that the temptation can be very strong to simply help yourself. If the image you select is copyright-free then there is no problem. If it is copyrighted, and the copyright holder exercises his or her rights, then the ease with which you were able to access it is no defense.

MORAL RIGHTS

Be also aware that artists possess moral rights to their work. If you substantially change the context of even a copyright-free image to the point where its original intention has been grossly distorted, you might encounter problems. These problems can include your work being dismissed as naive or gauche, corrupt or offensive, and depending on the level of debate, can become a legal matter.

WHAT MATERIAL CAN YOU SAFELY USE?

Creative material is protected by copyright. When this copyright expires it is said to be in the public domain. The general rule of thumb is that if an image was published before 1922, it is in the public domain and you are free to use it (subject to the provisos discussed above). However, it is wise to assume that all images are protected and accordingly you should seek permission from the copyright holder. Even images produced prior to 1922, and held in public collections, have restrictions on their use. The institution that holds these works might have the authority to grant permission if you wish to use one of the images from its collection.

The other method is simple. Ask the copyright holder, usually a fellow artist, for permission to use his or her work. I do this all the time. It is actually great fun and you get to meet and speak with many interesting people. I have never been denied permission. In the majority of cases the person is happy that you are interested in their work and pleased if you send them a copy of your work when it is finished. However, finding copyright holders can be difficult if the artist is deceased, but his or her work still protected. Simply see this as an opportunity to do some fun detective work. The only occasions when I have encountered problems is when an agency is administering an artist's work or estate. These agencies make their living by collecting a fee and taking a commission on such transactions. Unlike individual artists they do not (and probably as disinterested bureaucrats cannot) enter into the spirit of your project. As far as they are concerned you could be a major publisher or TV network. As such they can be quite tough and can ask for a lot of money. Usually, however, they have a non-profit or individual artist rate so do not be afraid to ask for a better price. Simply explain the nature and scope of your project and the context in which the work will appear. If your usage is modest, so usually is the fee.

WHAT MATERIAL CAN YOU LESS SAFELY USE?

THE DOCTRINE OF FAIR USE

There are legitimate ways to use limited amounts of copyrighted material. This is known as fair use. This is a gray area but one that accords students, in the course of their studies, more leeway than commercial artists or professional fine artists enjoy. The following guidelines are from the U.S. Government's website www.copyright.gov/fls/fl102.html.* To quote:

** I went to the website to get this information for the purposes of this discussion. I dutifully copied and pasted the information into my manuscript. A moment of terror ensued. "Did I just infringe the U.S. Government's copyright?" I called the Copyright Office and of course was unable to speak to a real, live person. I then called my attorney who wrote me the following email:*

Douglas
I am not sure if the US Copyright office's materials are copyrighted. You might be able to use them being this is from a government agency. If I had to guess, I'd say you could likely use it. I am not a copyright attorney and I do not warrant a thing about this impression. It is not legal advice for that purpose and no better than the usual bar room B.S!

One of the rights accorded to the owner of copyright is the right to reproduce or to authorize others to reproduce the work in copies or phonorecords. This right is subject to certain limitations found in sections 107 through 118 of the copyright law (title 17, U. S. Code). One of the more important limitations is the doctrine of "fair use." The doctrine of fair use has developed through a substantial number of court decisions over the years and has been codified in section 107 of the copyright law.

Section 107 contains a list of the various purposes for which the reproduction of a particular work may be considered fair, such as criticism, comment, news reporting, teaching, scholarship and research. Section 107 also sets out four factors to be considered in determining whether or not a particular use is fair:

1. The purpose and character of the use, including whether such use is of commercial nature or is for nonprofit educational purposes.
2. The nature of the copyrighted work.
3. The amount and substantiality of the portion used in relation to the copyrighted work as a whole.
4. The effect of the use upon the potential market for, or value of, the copyrighted work.

The advice also includes the following provisos:

The distinction between fair use and infringement may be unclear and not easily defined. There is no specific number of words, lines, or notes that may safely be taken without permission. Acknowledging the source of the copyrighted material does not substitute for obtaining permission.

The 1961 Report of the Register of Copyrights on the General Revision of the U.S. Copyright Law cites examples of activities that courts have regarded as fair use:

1. Quotation of excerpts in a review or criticism for purposes of illustration or comment; quotation of short passages in a scholarly or technical work
2. For illustration or clarification of the author's observations.
3. Use in a parody of some of the content of the work parodied.
4. Summary of an address or article, with brief quotations, in a news report.
5. Reproduction by a library of a portion of a work to replace part of a damaged copy.
6. Reproduction by a teacher or student of a small part of a work to illustrate a lesson.
7. Reproduction of a work in legislative or judicial proceedings or reports.
8. Incidental and fortuitous reproduction, in a newsreel or broadcast, of a work located in the scene of an event being reported.

Copyright protects the particular way an author has expressed himself. It does not extend to any ideas, systems, or factual information conveyed in the work.

The safest course is always to get permission from the copyright owner before using copyrighted material. The Copyright Office cannot give this permission.

When it is impracticable to obtain permission, use of copyrighted material should be avoided unless the doctrine of fair use would clearly apply to the situation. The Copyright Office can neither determine if a certain use may be considered fair

Follow up to previous sidebar:

After sending an email to the Copyright Office asking for clarification, several days later I received the following reply:
Copyright Protection is not generally available to Federal agencies: See 17 USC Section 105. Therefore, works such as our circulars and other Copyright Office publications are not subject to copyright protection and can be freely used.

Opposite: Copyright only protects the expression of an idea, not the idea itself. Otherwise we could imagine a rather nasty courtroom battle between the ancient Egyptians and the Maya, fighting over the rights to build pyramids! Trouble Brewing. *Image by the author. 2009.*

nor advise on possible copyright violations. If there is any doubt, it is advisable to consult an attorney. *(End quote.*)*

CONCLUSION

** Reference: FL-102, Revised May 2009 Home | Contact Us | Legal Notices | Freedom of Information Act (FOIA) | Library of Congress U.S. Copyright Office, 101 Independence Avenue SE_ Washington, DC 20559-6000 (202) 707-3000*

As you can see, there are exceptions. However, as you can also see there is no guarantee of protection should you claim fair use. Even attributing your source, the most basic and common courtesy, will not afford you any protection. My policy on this issue has been that if the work is produced for course requirements, and is not to be published commercially or otherwise widely distributed, then as long as all sources are properly cited and attributed, minimal use of the work of others is OK. It has always struck me as curious that if you are constructing a written paper, then the more sources you cite, the more you are perceived as a well-read and informed scholar. However, should you do the same thing with images, you run the risk of being labeled a plagiarist. Why is this so? To not admit to influence is to deny reality.

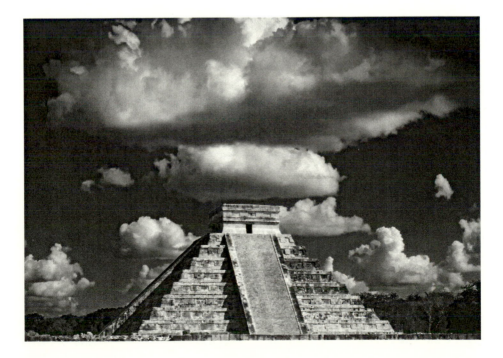

PROTECTING YOUR WORK

CONVENTIONAL COPYRIGHT—ALL RIGHTS RESERVED

The discussion until now has been centered on respecting the rights of others. However, as a creative author, you have rights as well. Prior to 1978, to protect your work you had to place a copyright notice on your book and register it with the United States Copyright Office. However, the law now protects creative work the moment it is placed in tangible form. This protection extends to 50 years after your death.

It is no longer necessary to register your work with the Copyright Office to gain this protection. This will only be required if you wish to sue for copyright infringement. However, it is wise to place a notice in your book claiming copyright. This notice must include the following information:

For more information contact:
The Copyright Office, Library of Congress URL: www.loc. gov/copyright

1. The word "Copyright" or the symbol "©."
2. The year of first publication.
3. Your name, or that of the copyright holder.

CREATIVE COMMONS—STIPULATED RIGHTS RESERVED

If your work uses images from a variety of outside sources you might wish to consider extending to others the courtesy that has been extended to you. Rather than reserving all rights, as is the case with conventional copyright, you can instead grant certain stipulated rights. One way to do this is to register your work with Creative Commons.

Creative Commons* is a non-profit organization that is committed to making information more widely available. It offers to artists and other creators a way of protecting their work but at the same time allowing the artist to grant as many or as few rights as you so decide.

Creative Commons was founded in 2001 with the support of the Center for the Public Domain. It is led by a Board of Directors that includes cyberlaw and intellectual property

** The following description of their mission is from their website: http:// creativecommons.org*

Sometimes it can seem like there are eyes everywhere.
Philadelphia Dream. *Image by the author. 2009.*

experts Michael Carroll, Molly Shaffer Van Houweling and Lawrence Lessig, MIT computer science professor Hal Abelson, lawyer-turned-documentary filmmaker-turned-cyberlaw expert Eric Saltzman, renowned documentary filmmaker Davis Guggenheim, noted Japanese entrepreneur Joi Ito and educator and journalist Esther Wojcicki.

In December 2002, Creative Commons released its first set of copyright licenses for free to the public. Creative Commons developed its licenses—inspired in part by the Free Software Foundation's GNU General Public License (GNU GPL)—alongside a Web application platform to help license works freely for certain uses, on certain conditions or dedicate works to the public domain.

In the years following the initial release, Creative Commons and its licenses have grown at an exponential rate around the world. The licenses have been further improved, and exported to over 50 international jurisdictions. Creative Commons is used by, among others, Google, Nine Inch Nails, the Public Library of Science, Wikipedia and Whitehouse.gov.

CONCLUSION

The purpose of this discussion has been to warn the reader of the many traps and pitfalls that can occur when using digital technology. Most of these problems will evaporate if your project is comprised entirely of your own work. It is anticipated that this will be the case for the majority of readers. However, as the discussion of image usage suggested, even basic concepts such as authorship and originality have been severely questioned, if not re-defined, because of the unique characteristics of digital technology and the ready availability of pre-digitized material on the Internet. When in doubt, try wherever possible to substitute an image of dubious title with either a known copyright-free image, one for which you have permission to use, or better still one of your own making.

Opposite: From The Sears, Roebuck and Co. Catalog. *Chicago, IL: 1902.*

GENERAL GOOD PRACTICE

The following simple rules will help guide your practice.

DO

- credit your sources, both text and images, in an accurate and academically responsible manner.
- acknowledge any assistance you may have received above and beyond normal help.

DO NOT

- do to other's work that you would not like done to yours.
- install software on your own computer that you have not obtained legally.
- use large (or small) quantities of un-attributed text.
- use other people's images as if they were yours.

Image from The Camera. *Philadelphia: The Camera Publishing Company, November 1918. Volume 17, Number 11.*

A NOTE ON THE ILLUSTRATIONS

I sometimes wonder if that which we call "progress"
is better described as a process of systematic forgetting.

As a teacher I am accustomed to reaching for a piece of chalk or an erasable marker to make a point in diagrammatic form. If I were a better draftsman I would have employed the same strategy in this volume. However, instead I have used many old, often enigmatic images, to function as diagrams to elaborate or comment upon certain key points. However, like photographs from this time, these images are rooted in a century-old reality. So they cannot function solely in the abstract realm of the explanatory diagram. A tension therefore is created as we attempt to compare these images of real things with the surrounding text and see no immediately apparent correlation. This raises the issue of what can images, particularly photographs and other highly reality-based forms of visual art, actually do?

Certainly they can describe the appearance of things, so much so that they run the risk of being perceived as a surrogate for those things. How many times do we look at an image of the world and speak as if we were looking at the mountains and trees themselves? I would argue, that like photographs, these illustrations from old catalogs and medical and scientific texts were equally determinably attempting to show us real things. However, there is a paradox at work. This revolves around the fact that these images show us a reality that we, as new-millenium laypersons, cannot really see. If you were to look inside a human skull you would not see a neat arrange-

ment of carefully executed lines and forms. Instead, more likely you would see a bloody, gelatinous mess. When we look at some of the illustrations from the century-old Sears catalog we are often looking at devices that bear no relationship whatsoever with anything within our current experience. Yet all these images referred to something that is or was once out there in the real world.

The other mechanism at work is that not only do these kinds of images try to describe something; they also try to explain it. They do this by showing the object stripped down and simplified. The paradox is, of course, that the process of visual isolation and simplification that is employed to make things clear to the informed viewer, to our eyes, reaches a point of critical confusion. The very precision of their description and the accuracy of their detail causes the images to almost sever their connection to the world as we know it. This can extend to the point where some begin to totter precariously on the border of total abstraction.

This is why I have used them to illustrate the book. At their best, these photo-like images of reality become abstract, plastic forms that have lost, for the most part, any meaning dependent on our knowledge of the reality that they once purported to depict. They have become documents of nothing. They have metamorphosed into isolated, self-referential facts waiting patiently to be re-assigned meaning by means of context. After all, what does "doubt" look like? We all know what "doubt" actually is far more than we know what our own brain actually looks like. However, what's its appearance? Similarly, what does software copyright infringement look like?

I am not sure whether I know the answers to these two questions, or whether I am just speculating. However, I do know either is very hard to photograph! The moral of the story is clear—it is perhaps just as important to know what photography cannot do as well as what it can.

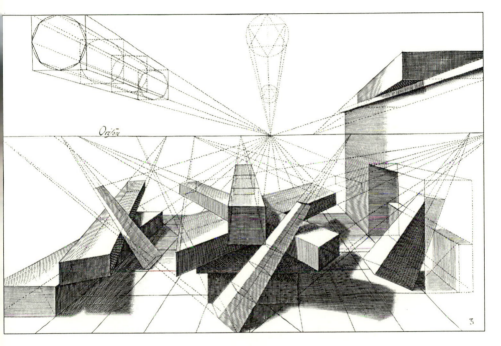

Image by Van Vrederman de Vries. Perspective. *ibid.*

BIBLIOGRAPHY

RESOURCES USED IN THIS VOLUME:

Barrett, Terry *Criticizing Photographs*. London and Toronto: Mayfield Publishing Company, 1990.

The Camera. Philadelphia: The Camera Publishing Company, .
 November 1903. Volume 7, Number 12.
 November 1903. Volume 7, Number 1.
 November 1907. Volume 11, Number 12.
 November 1918. Volume 17, Number 11

Cirlot, J. E. *A Dictionary of Symbols*. New York: The Philosophical Library, 1962.

The Encyclopedia of Source Illustrations, a facsimile volume comprising all of the 266 plates contained in The Iconographic Encyclopedia of 1851. Hastings-on-Hudson, NY: Morgan and Morgan, 1972.

Freud, Sigmund. *Revision of the Theory of Dreams* in *New Introductory Lectures on Psycho-analysis*. New York: Carlton House, 1933.

Gatewood, Charles. *Photography for Perverts*. Oakland, CA: Greenery Press, 2003.

Killian, Dr. Gustav. *The Accessory Sinuses of the Nose and their Relations to Neighboring Parts*. Jena: Gustav Fischer, 1904.

Les Mille & un Tours, ou Expériences de Physique Amusante et de Magie Blanche. Paris: ANA-GRAMME BLISMON, 1869.

Merton, Holmes W. *Descriptive Mentality from the Head, Face and Hand*. Philadelphia: David McKay Publisher, 1899.

Mitchell, W. J. *The Reconfigured Eye*. Cambridge, MA: MIT Press, 1994.

Physicians Anatomical Aid. London and New York: H. Andrews. Gen. Agent, Auckland, N.Z. c. 1895.

Sears, Roebuck and Co. Catalog. Chicago, IL: 1902.
Sears, Roebuck and Co. Catalog. Chicago, IL: 1927.
Vrederman de Vries, Jan. *Perspective.* With a New Introduction
by Adolf K. Plaaczeck. New York, NY: Dover Publication,
Inc., 1968. (Reprint of 1604/5 book.)

AUTHOR'S BOOKS USED IN THIS VOLUME

Paper, Scissors and Stone. Woodford, NSW: Rockcorry, 1995.
Digital Book Design and Publishing. Rochester, NY: Clarellen,
2001.
Secrets of the Spread. Rochester, NY: 2005.
Veronica. Rochester, NY: Clarellen, 2006.
Photo-Editing and Presentation. Rochester, NY: Clarellen, 2009.
Your Assignment: Photography. Rochester, NY: Clarellen, 2009.

OTHER USEFUL TEXTS

Bayles, David and Ted Orland. *Art and Fear.* Santa Cruz, CA and
Eugene, OR: The Image Continuum, 1993.
Lyons, Nathan. *Photographers on Photography.* Englewood Cliffs,
NJ: Prentice-Hall, Inc., 1966.

USEFUL WEBSITES

US Copyright Office, Library of Congress. www.loc.gov/copyright
Creative Commons. http://creativecommons.org
Author's website. www.clarellen.com

ACKNOWLEDGEMENTS

I would like to thank all my teachers, colleagues and students for their input, advice, criticism and support over the years.

Special thanks are extended to Dr. Peter Stanbury for giving me access to his wonderful collection of Victorian-era books and permitting me to photograph them. Additionally I would like to thank Dr. Stanbury for his helpful comments and suggestions as the writing of the text proceeded.

Thanks also to Professor Nathan Lyons and Joan Lyons for their comments and advice as the work developed.

Thanks are also extended to the *Victoria and Albert Museum of Childhood* in London, UK, for permission to use the image of the Snakes and Ladders game on page 64.

I would also like to thank Arlene May of the Sears Holdings Archives for granting me permission to use images from the *Sears® Catalogs* of 1902 and 1927.

For invaluable comments and corrections, special thanks are extended to Beverly Hettig and Professor Jan Kather of Elmira College, NY. I would also like to thank Marlene Seidman of the Visual Studies Workshop, for her comments about the Aldus story and Dr. Robert Boswell's comments about the structure of the chapter *The Hidden Curriculum*.

Editing and final proofreading by Karen vanMeenen, Editor of the journal *Afterimage*.

APPENDICES

This volume is the third in a series of three books that address issues related to photographic education. The series is entitled *Photo Developing*. The other two books are *Your Assignment: Photography* and *Photo-Editing and Presentation*.

To give the reader a sense of the entire series, and how they inter-relate with each other, I have decided to include brief summaries of these other books.

Please be aware that as a function of the editing process, the book you are reading now was produced last—yet from a student's perspective, should be read first. Therefore, the series should ideally be seen in the following order:

- *Studying Photography: A Survival Guide*
- *Your Assignment: Photography*
- *Photo-Editing and Presentation*

Seeing the entire series in this abbreviated manner should assist you, the reader, to further understand the sequence of steps involved in a course of study of this most complex, and indeed remarkable, medium.

For further information, or to purchase copies of any or all of the books, please visit my website CLARELLEN.com

Douglas Holleley
Rochester, NY
2010

Above: Douglas Holleley. (With an Introduction by Nathan Lyons.)
Your Assignment: Photography. *Rochester, NY: Clarellen, 2009.*
ISBN 978-0-9707138-7-2

APPENDIX I
YOUR ASSIGNMENT: PHOTOGRAPHY

*The essential intent of the assignments is self-discovery. This book reminds readers that fundamental purposes should always be remembered and respected. Teachers in art and photography programs would do well to incorporate these ideas into their courses. Indeed, anyone interested in the visual arts, whether currently involved in education or not, will enjoy and learn from this book, which offers appealing, cogent prose and insightful illustrations.**

SUMMARY

** Review excerpt from* Choice *magazine, February 2010, Vol. 47, No. 06. R. M. Labuz, Mohawk Valley Community College.*

The art of photography can help us see ourselves just as much as it can help us see the world around us. But just how does photography become an act of self-discovery? How can we create images with meaning and resonance?

This book is a comprehensive curriculum of photography expressed as a series of questions and/or problems. It addresses not only the acquisition of photographic skills and techniques, but also shows us how we can recognize the signs, and understand the meanings, contained within the images we make. The exercises in this book will enable both beginners and advanced students of photography to sharpen their abilities and enhance their awareness of themselves and the world.

Teachers will find inside this volume a well-reasoned and coherent curriculum. It provides many valuable resources they can share with their class. Students will gain a greater understanding of the process of photographic education because each assignment is accompanied by a detailed rationale that explains not only what is being asked of them, but more importantly, why.

CHAPTER ONE: EXPLORING THE MEDIUM
Assignments Based on Technical or Process Issues

This chapter examines a variety of ways to introduce students to the basic building blocks of the medium. At first glance these processes might look deceptively simple. However, if undertaken seriously and joyously, they can produce work of great beauty and interest. Just as importantly, they provide insights into the medium at a very fundamental level, which can then be transferred to more sophisticated technical processes.

CHAPTER TWO: THE EYE
Assignments Based on
Perceptual and/or Observational Issues

This chapter is comprised of two sections. Part One, *Light and Color,* is devoted to sharpening one's observational skills. In the first instance, in deference to tradition (or more likely habit) the principles address black and white photography. Subsequently the particular demands of color photography are discussed in detail.

Part Two, *Time and Space,* acknowledges that images are seen, and subsequently made, in a space/time continuum. Accordingly, the discussion and the assignments address how these elements might be consciously incorporated into the subject matter of the image.

CHAPTER THREE: THE "I"
Assignments on Developing a Sense of Self

This chapter addresses the issues of identity and self-image. Part One, *The Self,* examines the most direct route—the self portrait. More importantly, it addresses the fact that the self portrait can be more than just an image where the photographer happens to be in the picture. It also examines the idea that other objects and events can function as a metaphor for the self.

Part Two, *The Self and The World*, addresses the notion that every image, in its own way, can be a self-portrait—but only if we are fully aware of what we are doing, and why we are doing it.

CHAPTER FOUR: THE MIND
Assignments Based on Developing Cognitive and Reasoning Skills

The issues and assignments in this chapter are all concerned with the domain of the mind. All involve a process of analysis, the questioning of assumptions and the constant re-evaluation of one's own practice.

Part One, *On History and Research*, advocates that the student read both widely and critically the various histories of the medium and use this research to develop hypotheses that will facilitate the generation of work.

Part Two, *On Evidence* and Part Three, *On Words and Images*, also address issues of a theoretical nature. They will help the reader understand and be able to employ, a knowledge of contemporary theory and practice to inform and enrich his—or her work.

Right: A spread view showing the final assignment in Your Assignment: Photography. *This assignment suggests how your work can improve, and your thinking can embrace complexity, if you consider yourself, even if only for a moment, as an author rather than a photographer. Image by the author.*

Above: Douglas Holleley. Photo-Editing and Presentation. *Rochester, NY: Clarellen, 2009. ISBN 978-0-9707138-5-8*

APPENDIX II
PHOTO-EDITING AND PRESENTATION

*This book is a superbly designed and illustrated introduction to the successful presentation of a single image and an entire visual portfolio. After laying the intellectual foundation, Holleley provides a splendid review of appropriate processes, offering students and practitioners articulate ideas, effectively charted, that will assist in making visual ideas more interesting and more coherent.**

SUMMARY

* *Review excerpt from* Choice *magazine, November 2009, Vol. 47, No. 03. R. M. Labuz, Mohawk Valley Community College.*

This book introduces photographers, print-makers, and other graphic artists to the creative possibilities of image editing and presentation. The focus is on how meaning can be created and shaped if the emphasis is placed on the totality of the visual experience rather than by looking at each single image in isolation.

In the first instance, there is a discussion of a variety of ways images can be grouped together. This act has implications for how the work should subsequently be presented. To this end there is a discussion of various presentation techniques, and how each different forum can further amplify the desired effect. Finally there is a hands-on look at a variety of presentation techniques such as artist book publishing, exhibition design and portfolio construction that will help the reader to present his or her work in a professional manner.

By employing the principles outlined in this book readers can expect that the content of their work will be more coherent and accessible, not only to an audience, but also more importantly to themselves.

CHAPTER 1
BASIC EDITING STRATEGIES

All photography is a process of selection. Initially the photog-rapher goes out into the world and selects slivers of time and space. Subsequently, after the images are processed, individual images are selected from the proof sheet and printed. Finally there comes a stage when these images accumulate to the point at which another selection process comes into play. This final stage is called editing. However, this simple term under-states the importance of this act. More correctly, it is literally the creation of meaning. This chapter outlines in detail, vari-ous systems to assist the reader in this task.

CHAPTER 2
MACRO EDITING SYSTEMS

A thoughtful effort to address the totality of your finished work is preferable to an often-quixotic search for the *Great Image*. Besides, in many ways it could be argued that the world has enough great images—but whether we have a concomitant level of understanding of them is something else. At the end of the day our task is to create, or find, meaning. To do this we need to create a context within which our images can be both seen, and more importantly, interpreted and understood.

To this end this chapter discusses organizational structures of a more macro, rather than picture-to-picture, nature. Be aware that these systems have two functions. The most obvious of these is to present the work to the viewer in a professional, coherent, accessible and indeed beautiful, manner.

More importantly, however, is the fact that in responding to the demands imposed by these systems, the actual content of the work may be clarified by and to, one's self.

The systems discussed are, grouping, the narrative, the sustained metaphor (or sequence), the array, assemblage, the moving image and finally, diagrammatic systems. Issues related to successfully contextualizing your work are also addressed.

CHAPTER 3
PRESENTATION

The form of presentation you choose can/will affect the very meaning of your photographs. This chapter looks at the variety of presentation forms (or more correctly, forums) available and examines the particular qualities and potential(s) of each.

After a discussion of scale, seven major presentation forums are examined. They are: the book, the portfolio, the book/portfolio hybrid, the exhibition, the installation, time-based methods and electronic delivery systems.

CHAPTER 4
PRESENTATION TECHNIQUES

In this chapter, a variety of methods for presenting work are discussed and clear directions for their construction are included. All of the methods are within the ability of any careful and patient person, and all will help make your work both more beautiful and more accessible to your audience.

The reader will be shown how to make books and portfolio cases as well as mat prints. The case is also made for producing prints that need no further embellishment in order to be successfully presented.

Right: A spread view from Photo-Editing and Presentation *showing the construction of a hard-cover concertina book. Such books are easy to construct and communicate a wonderful impression, far in excess of the effort expended in making them. Image by the author.*

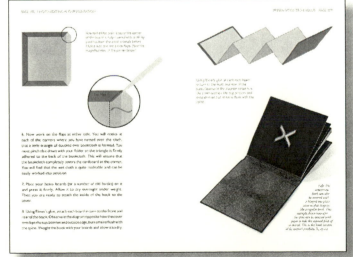

INDEX

Symbols

© 98
9/11 69
35mm 11, 14, 15, 82

A

Academia, the ways of 17
Academic honesty and cour-
 tesy 65–69
Acknowledgements 108
Adams, Ansel 53
Adobe InDesign 82
Afterimage 38, 108
Aldus 67
Allthethingsthatcangowrong
 69
ANALYZING PHOTO-
 GRAPHS 23–45
 Introduction 23
 Analytical approach 24
 Description, importance
 of 25
 Interpreting photographs
 29
 Subject of the image 29
 Intuitive (patient) ap-
 proach 33
 Participatory approach
 37
 Formal and/or structural
 approaches 41
 Class feedback and criti-
 cism 42–44

Judging Photographs 45
APPENDICES 109–117
Appendix I, *Your Assignment:
 Photography* 111–113
Appendix II, *Photo-Editing and
 Presentation* 114–117
Application for job 82
Arbitrary hierarchies 15
Archetype 31
Art history 31
Artist 19, 20
Artist statement 42, 43, 50,
 51, 60, 66
 WRITING 51–53
Art theory 31
ASSESSMENT 59–63

B

Barrett, Terry. 30
Basic photography 15
Bibliography 106–107
Black and white 15
Body language 60
Bullying 61

C

Camera etiquette 66
Camera, The (magazine) Volume
 11, Number 12. 53,
 61, 67
Camera, The (magazine) Volume
 17, Number 11. 21,
 57, 102
Capitalism 31
CD Rom work samples 82
Cirlot, J. E. 13
Class 29, 37, 38, 42, 45, 55, 56,
 65, 74, 76, 111
 Value of 55–57
Classroom 29, 37, 38, 42, 45,
 55, 56, 65, 74, 76
Clone 89, 92
Collage 93
Color photography 15
Communication skills 21

COMPUTERS, COPYRIGHT
 AND THE LAW
 87–100
Computers
 Problematical nature of
 88–91
 Identical copy 88
 Original, compared to
 Copy 89
 Homogenization of data
 90
 Copy, cost of making 90
CONTENTS, TABLE OF 5
Context 29, 30, 44, 52, 93, 94,
 104
COPYRIGHT 87–100
 Conventional 98
 Image 93
 Software 92
 Text 92
 Creative Commons
 98–99
 Copyright Office 95, 96,
 97, 98, 107
 Other 100, 104, 107
Critical thinking 20
Criticism 20, 60, 61, 63, 75, 95,
 96, 108
 of your work 60
 See also Analyzing Photo-
 graphs
Curriculum
 default 18
 See also Hidden Curricu-
 lum)
Curriculum Vitae 80
Cyberlaw 98

D

Dada 91
Degree, formal 79
Digital Book Design and Publish-
 ing 36, 83, 84, 87, 107
Doubt 59, 68, 80, 87, 97, 100,
 104
 coping with 57
Dreams 25, 27, 30

E

Editing, a useful strategy 38
Encyclopedia of Source Illustra-
 tions 25, 54, 58, 63, 106
Episodic effort and growth 16
Ethernet 92
Evidence 113
EXCUSES 101 74–75
Exodus 20:4 69
Experiment, as excuse 75

F

Fair use 66, 87, 95
FEEDBACK, OBTAINING
 55–57
Feminism 31
Fleming, Alexander 75
Forgery 91
Formal written critique 42
Freud, Sigmund. 30

G

Gatewood, Charles 68
Good practice 101
Google 100
Graduate school 12, 18, 47,
 56, 78, 81, 82, 83
Graduate student 53
Groupthink 19

H

HIDDEN CURRICULUM
 11–21
 Over-shooting 12
 Incremental progress 14
 Arbitrary hierarchies 15
 Episodic effort and
 growth 16
 Ways of academia 17
 Subtle influence 18
 Fortuitous side effects
 19
 Other 5, 9, 57, 80, 108
History, photo 113

Holleley, Douglas 1, 3, 4, 8, 10,
 27, 30, 32, 34, 36, 39,
 46, 69, 70, 82, 84, 86,
 91, 97, 99, 109
House style 19

I

Idolatry 69
Incremental progress 14
Indesign, Adobe 82
Influence 18
Intellectual property 98
Intentionality
 Traps thereof 62.
 See also Progressing from
 Year to Year.
Internet 92, 93, 100
Interview for job or further
 study 83
INTRODUCTION 9

J

Jeopardy 44
Job
 See Interview for job
 See Application for job

L

Latent content 30
Leedskalnin, Edward 30
Lepler, Ed 38
Lessig, Lawrence 87, 100
Letter of application for a job
 or further study 81
Library of Congress 97, 98,
 107
Life Magazine 71
Lyons, Nathan 44, 108

M

Manifest Content 30
Mapplethorpe, Robert 29
Marxism 31

Mitchell, William 93
Modernism 53
Moral Rights 93
MS Word 82

N

Naiveté 53
Nine Inch Nails 100
Nonprofit 95
NOTE ON THE ILLUSTRA-
 TIONS 103

O

Over-shooting 12

P

Parody 18, 80, 96
Pastiche 87
PDF documents 82
Permission, seeking 94
Personal and professional
 skills 21
Photo-Developing 109
Photo-Editing and Presentation
 82, 84, 107, 109
 Summary 114–117
Picture Scrabble 38–39
Plagiarism 65, 97
Portfolio
 Design considerations
 83–85
 Reviews 56
Postmodern 87
Power, structures of 31
Premature Stylistic Enclosure
 72
Presentation 82–85, 107, 109,
 114–117
PROFESSIONAL PRACTICE,
 ASPECTS OF 79–85
PROGRESSING FROM YEAR
 TO YEAR 47–49
Progress, re-defined 103
Psychoanalysis 30
Public domain 4, 66, 94, 100

Q

QuarkXpress 82

R

Reading photographs 36
 See also Analyzing Photo-
 graphs
References to support job ap-
 plication 80
Research 113
Resume 80

S

Satire 66
Scrabble 38–39
Sears, Roebuck and Co. Catalog.
 Chicago, IL: 1902 13,
 14, 16, 17, 19, 44, 48,
 72, 78, 80, 92, 100, 107
Sears, Roebuck and Co. Catalog.
 Chicago, IL: 1927. 37,
 50, 74, 107
SELF-LIMITING TALK 71–73
Semiotics 30
Shindelman, Marnie 44
Shooting, as bad verb 12
Snakes and Ladders 64
Social theory 31
STATEMENT OF INTEN-
 TION, DEVISING A
 47–49
STUDENTS
 TYPES OF 76–77
 Other 9, 11, 12, 13, 15,
 16, 17, 18, 33, 37, 43,
 53, 55, 56, 65, 68, 72,
 74, 75, 76, 77, 80, 92,
 95, 96, 108
Sycophancy 17

T

TABLE OF CONTENTS 5

Teachers
 Influence of 18
 Other 9, 13, 15, 16, 18, 33,
 43, 44, 55, 56, 65, 72,
 76, 77, 96, 103, 108
 Text 46, 49, 82, 87, 92, 101,
 103, 108
Thesis 57
Time Magazine 71
Timetable, effects of 16
Torture 58
Transcript 79

V

Van Vrederman de Vries 40,
 105
Veronica 69
Victoria and Albert Museum of
 Childhood 64
Victorian 29, 108

W

Website, personal 81
White House, The 100
Wikipedia 100
Work samples for job or
 further study 82

Y

Your Assignment: Photograpy
 Summary 110–113

Opposite: Image from The
Camera. *Philadelphia: The
Camera Publishing Company,
November 1918. Volume 17,
Number 11.*

NOTES

Breinigsville, PA USA
24 February 2011
256267BV00001B/37/P